ポ〜ン
PONE
出水ぽすかアートブック
THE ART OF POSUKA DEMIZU

THE ART OF POSUKA DEMIZU

Author: Posuka Demizu
Editorial Design: Shunsuke Sugiyama
Translation: Pamela Miki / Christian Traylor / Brainwoods Corporation, Ltd.
Editor: Keiko Kinefuchi

Publisher: Hiromoto Miyoshi

PIE International Inc.
2-32-4 Minami-Otsuka, Toshima-ku, Tokyo 170-0005 JAPAN
comic@pie.co.jp

ISBN978-4-7562-4876-3 (Outside Japan)
Printed in Japan

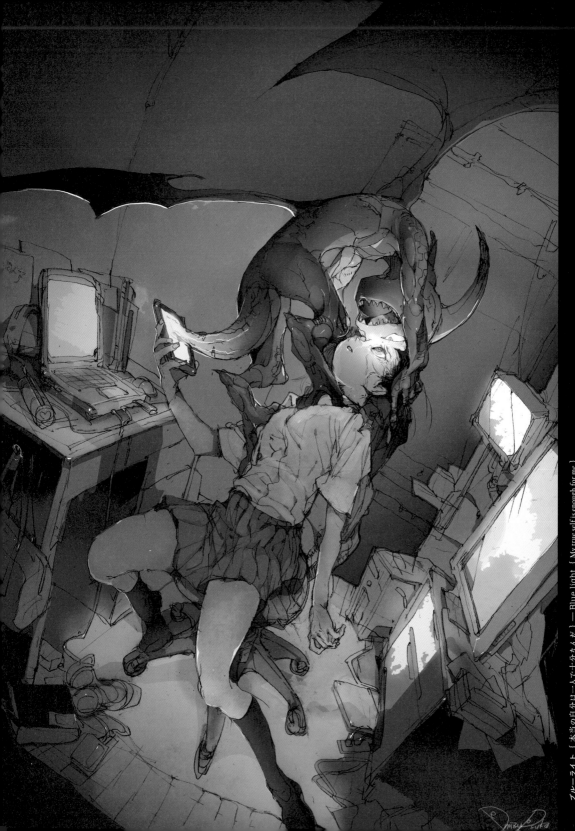

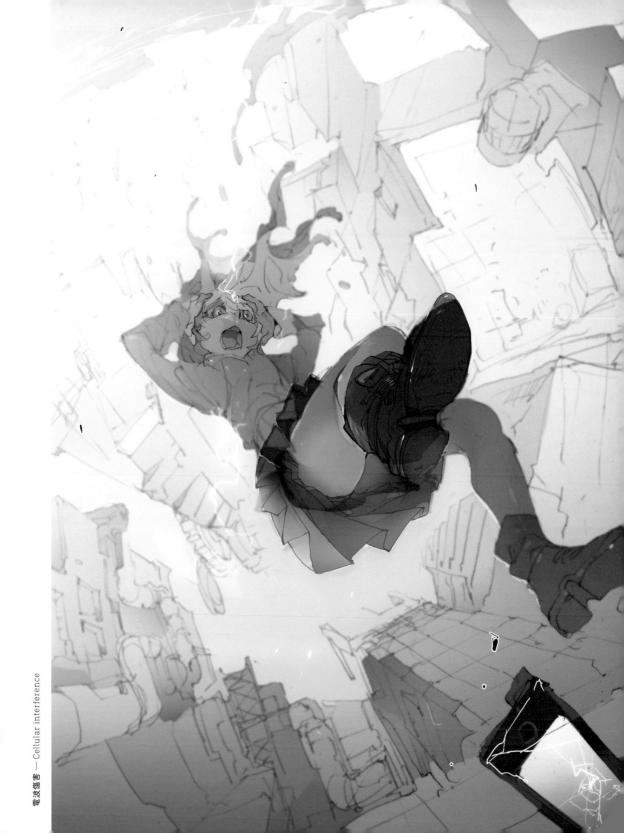

電波傷害 — Cellular interference

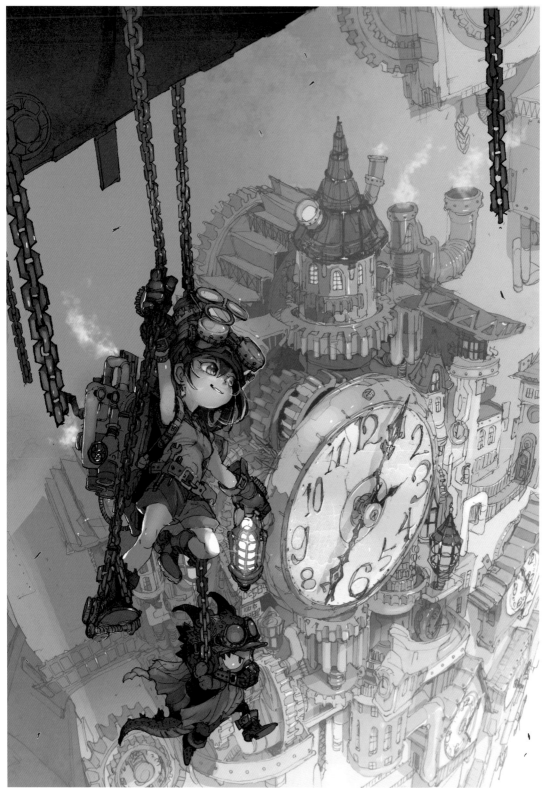

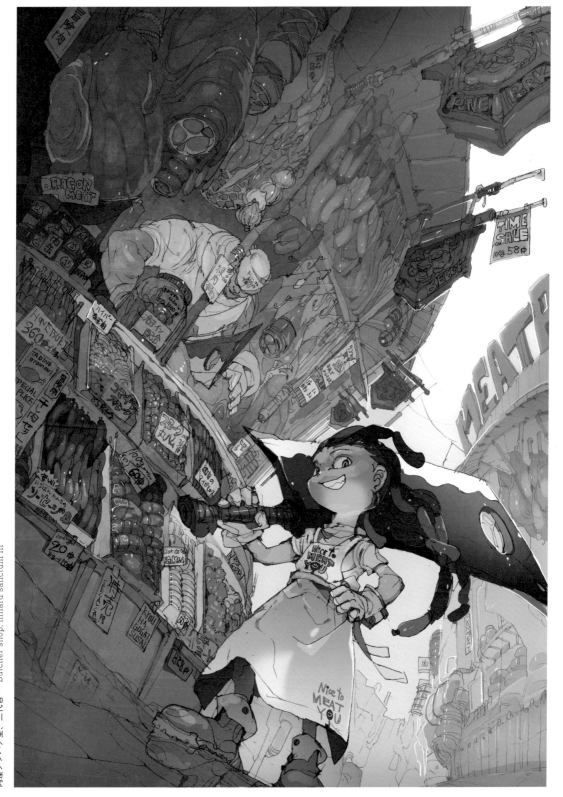

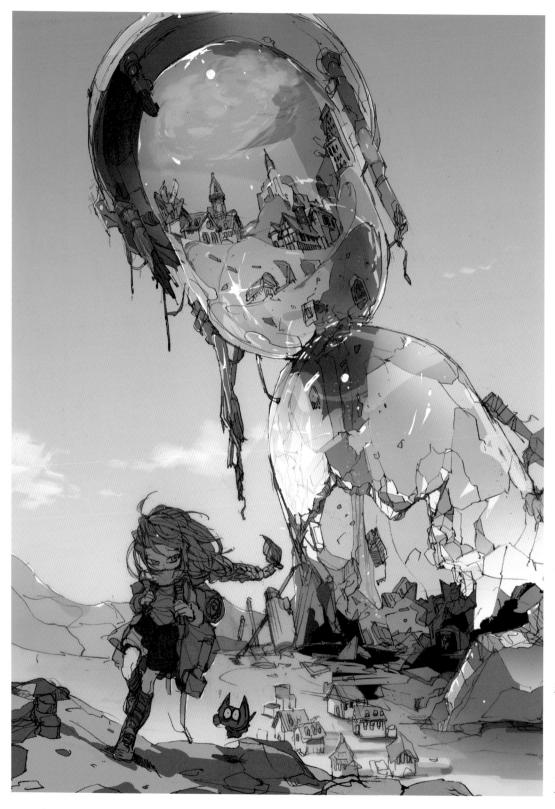

守られているのかもしれない〔閉じ込められているのかもしれない〕— A guardian angel?〔Or the captor?〕

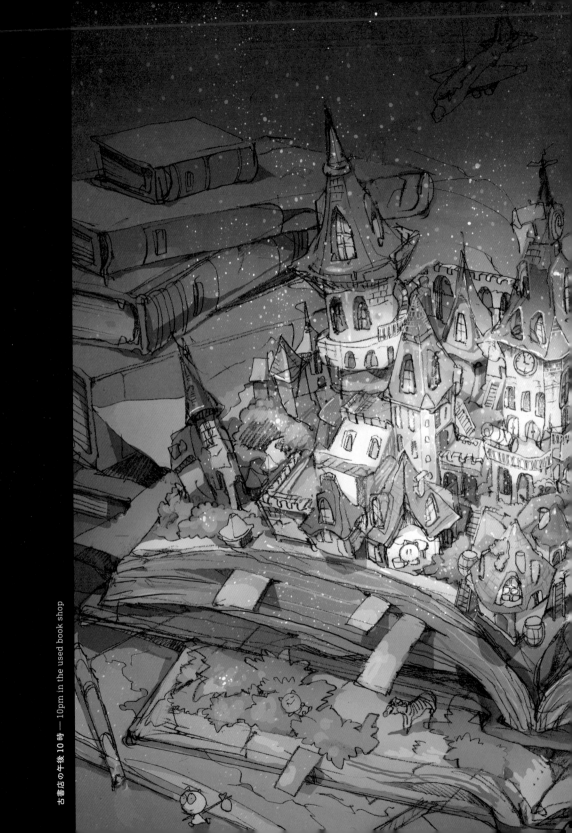

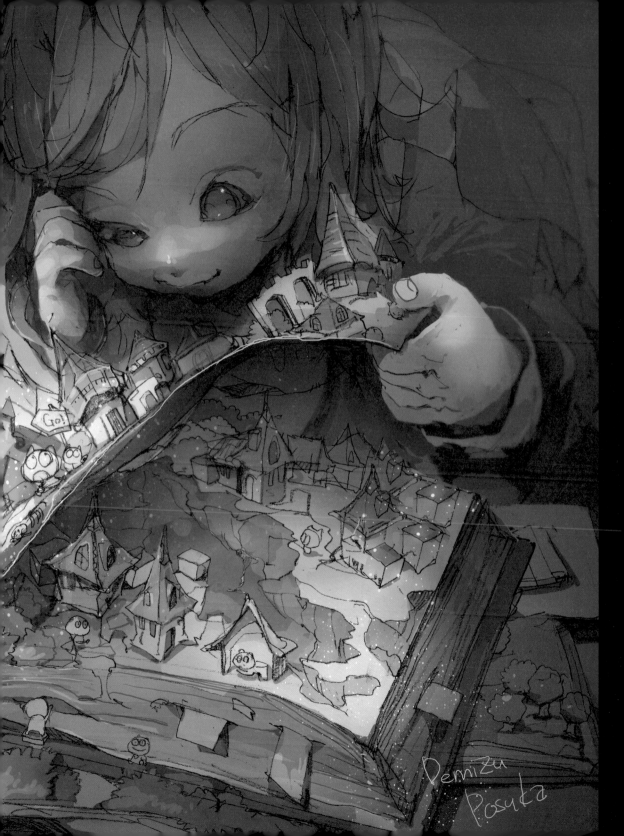

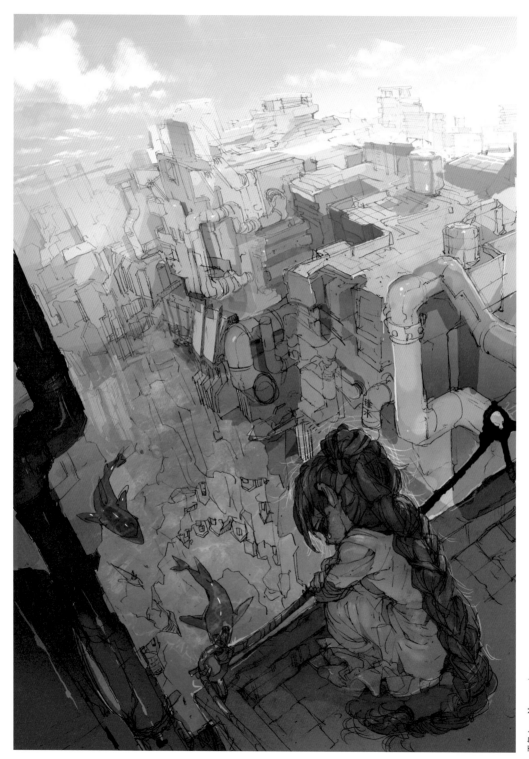

平気よ — No worries

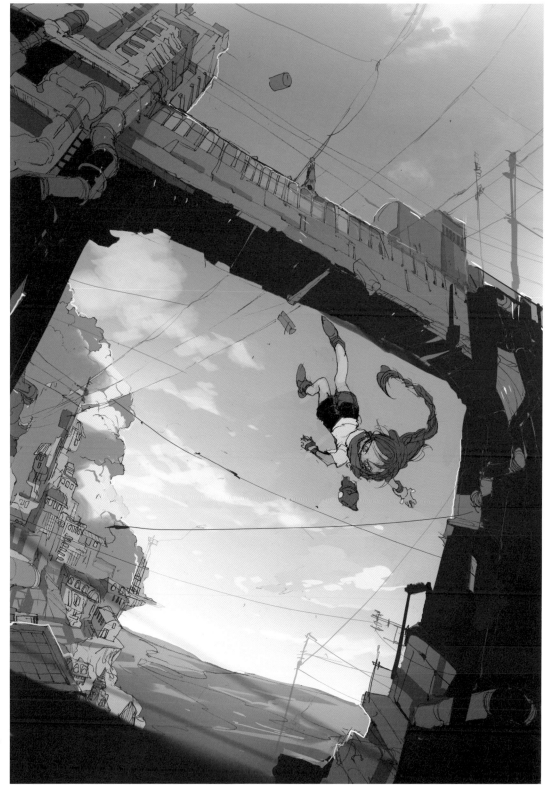

伝心 — High wire act

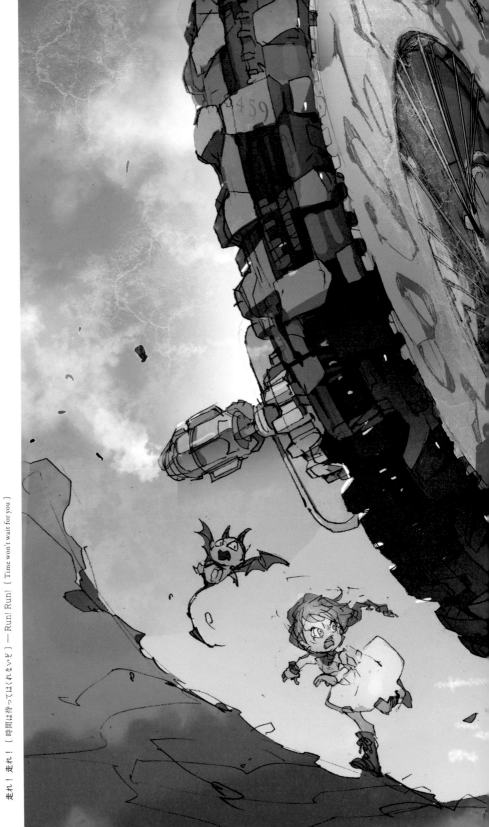

走れ！ 走れ！（時間は待ってはくれないと）― Run! Run!（Time won't wait for you）

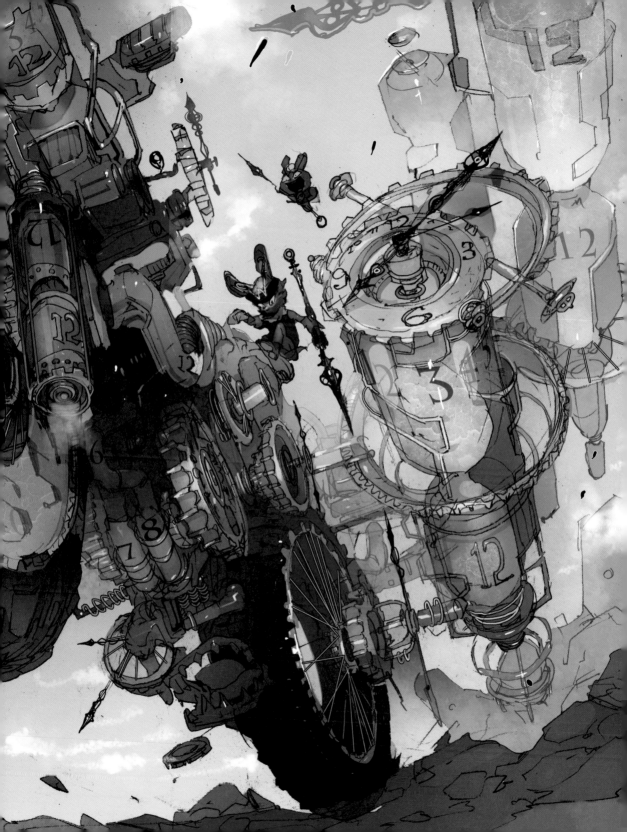

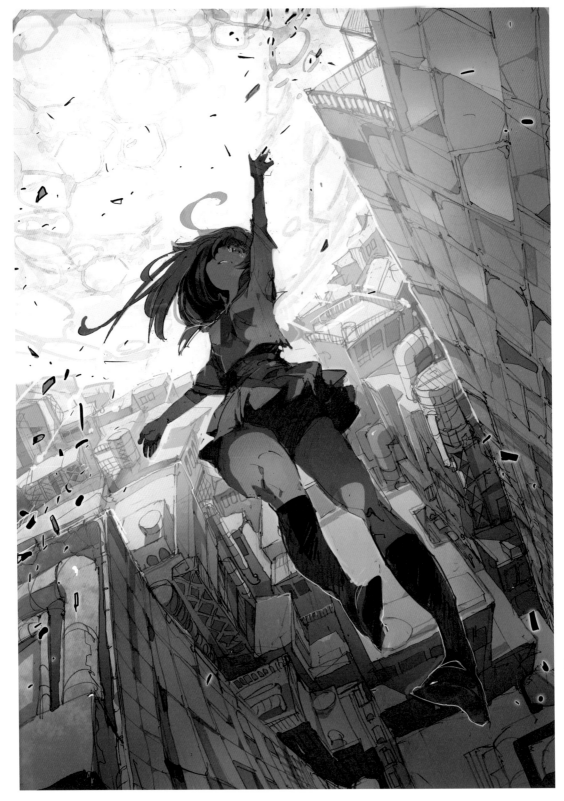

さよなら世界 — Good-bye world

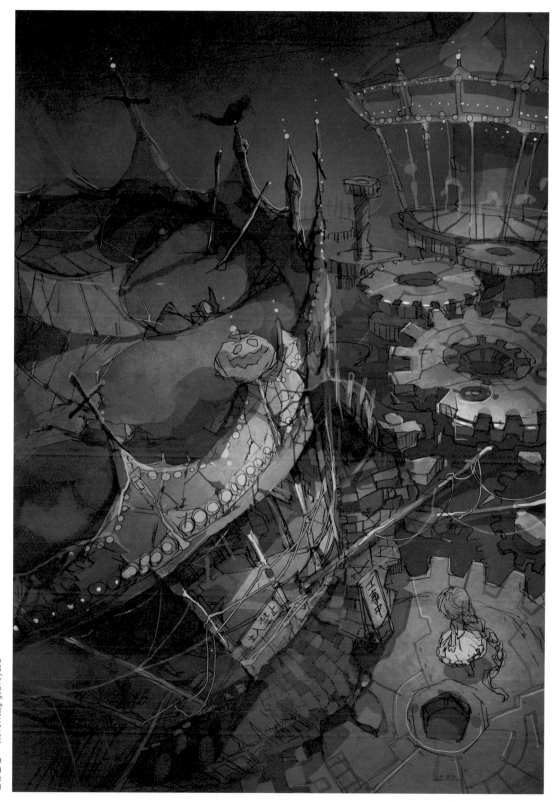

◎転墓場 — Revolving graveyard

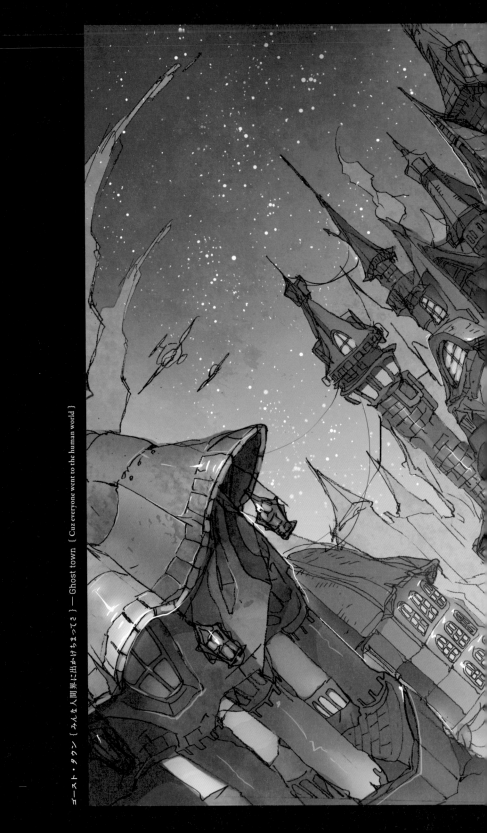

ゴースト・タウン〔みんな人間界に出かけちまってさ〕──Ghost town 〔 Cuz everyone went to the human world 〕

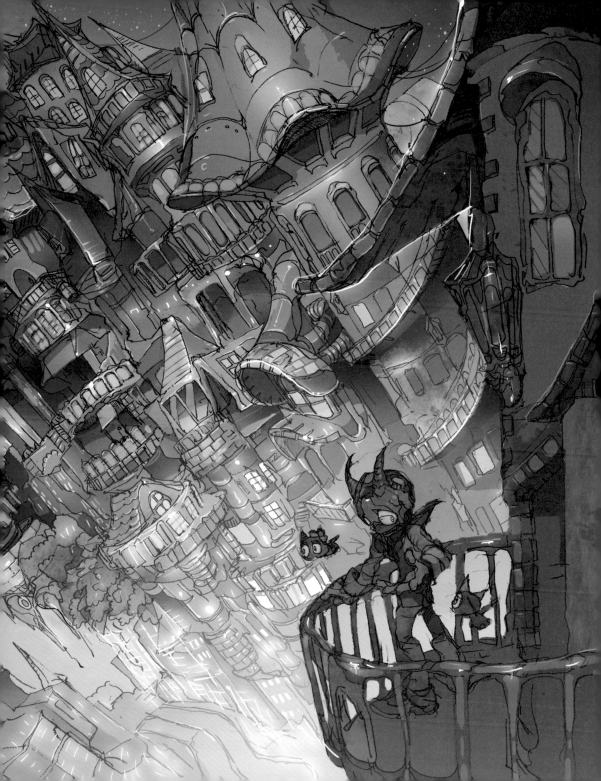

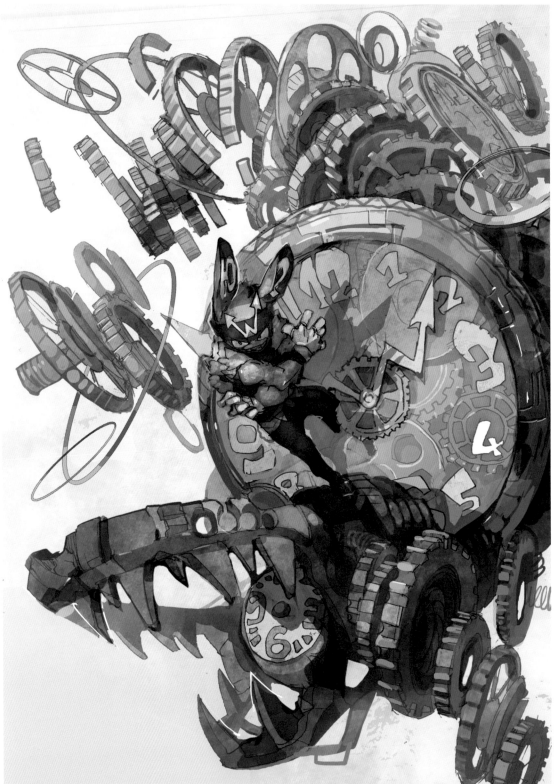

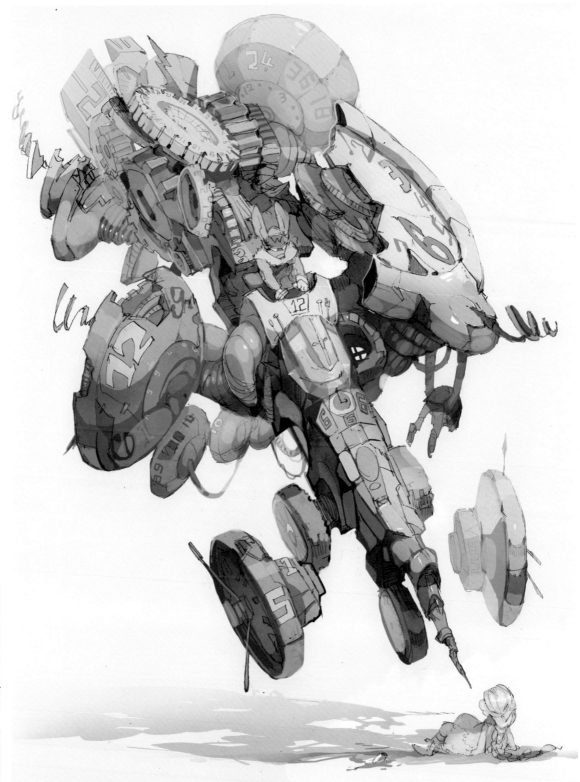

IB式時間操作機 — Old-style time control machine

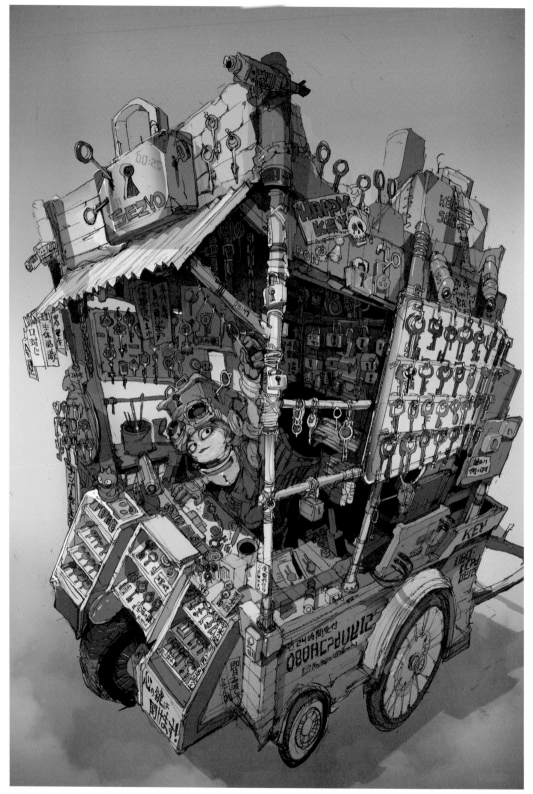

どのカギをお求めですか — What kind of key are you looking for?

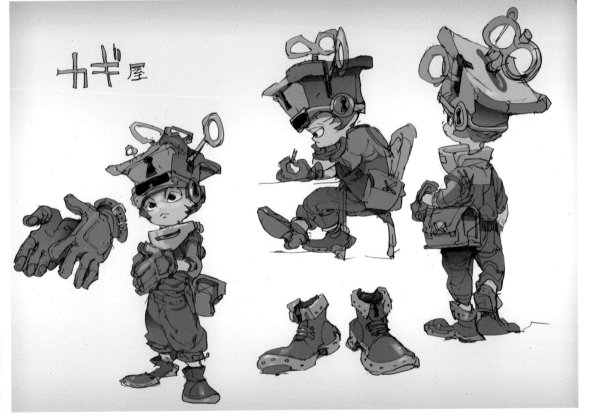

カギ屋

きみが昨日なくした戸棚のカギ、真夜中の教室へ忍び込むためのカギ、
未解決事件のカギ、隣のあいつの口を閉じるカギ、死人の目をこじ開けるカギ。
死者が誰かって？ 我々はちゃんと知っている。

That cabinet key you lost yesterday, the key to sneak into the midnight classroom,
the key from that unsolved case, the key to shut up your neighbor, the key to pry open the eyes of the dead.
Who died, you say? We know exactly who is dead.

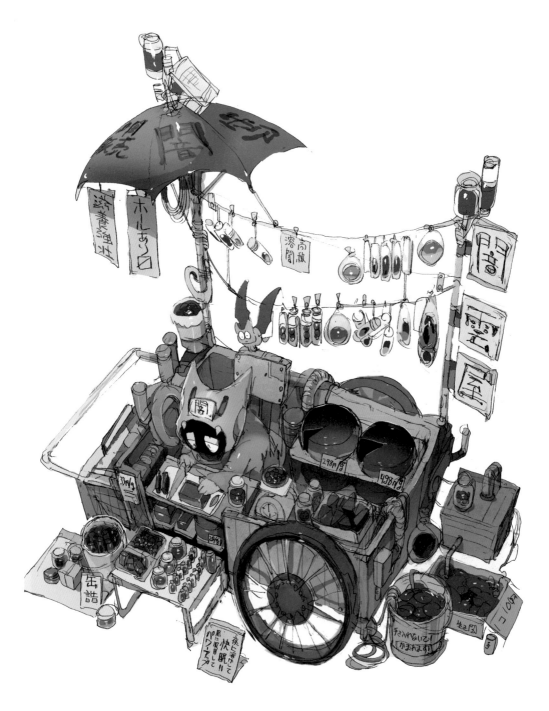

闇闇商店やみくも屋 ── Black-market Yamikumoya

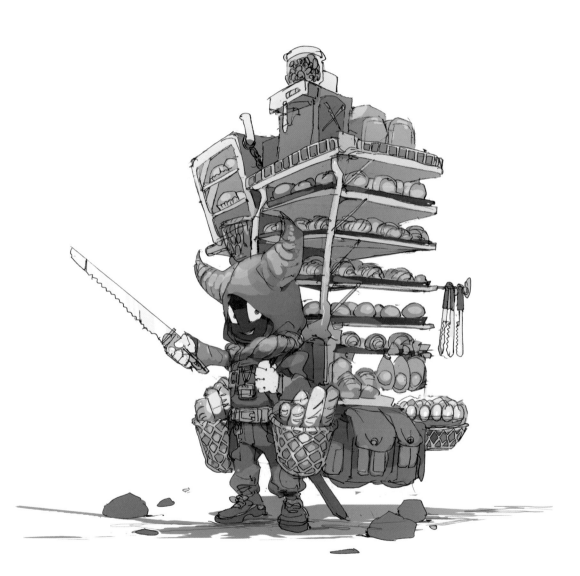

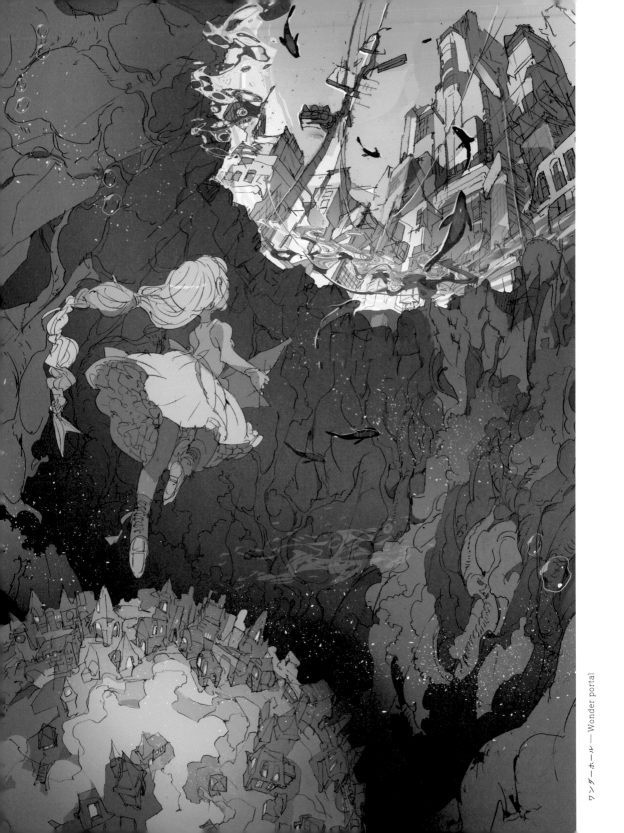

ワンダーホール — Wonder portal

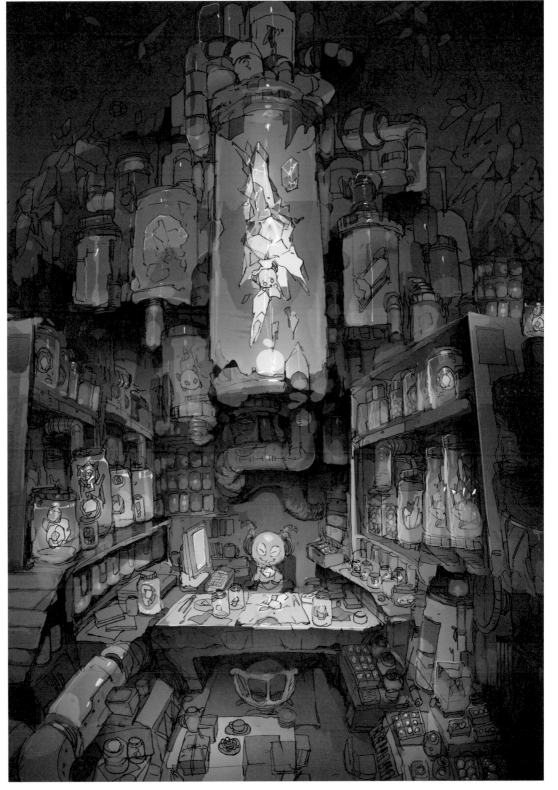

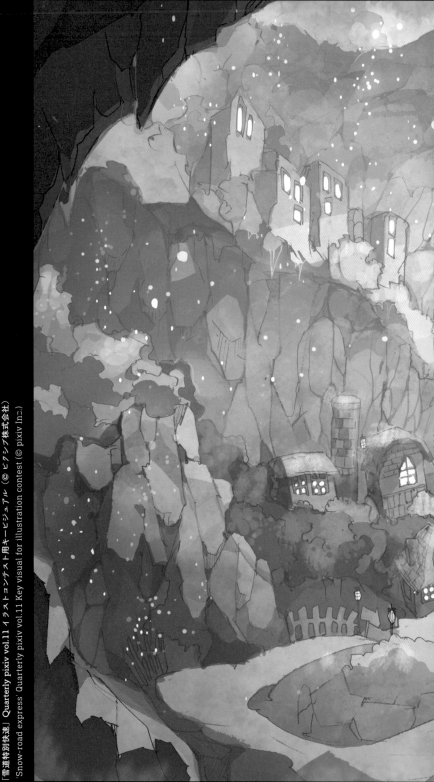

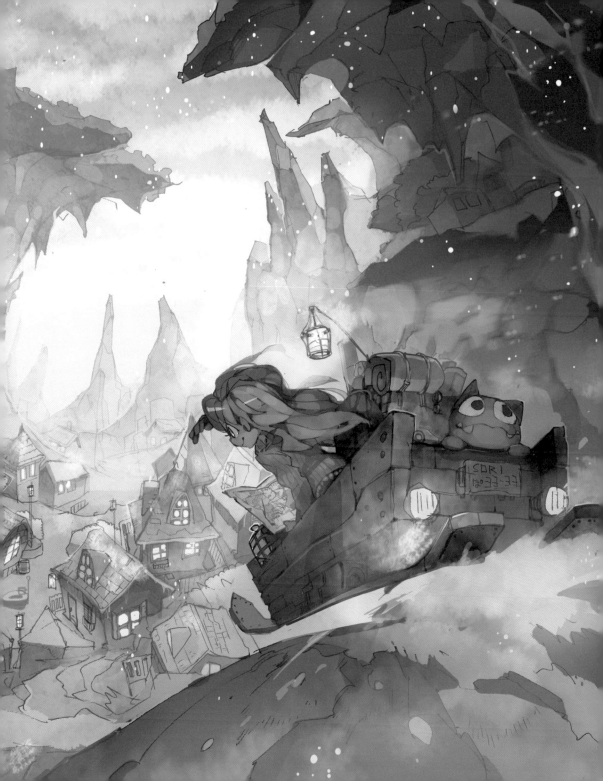

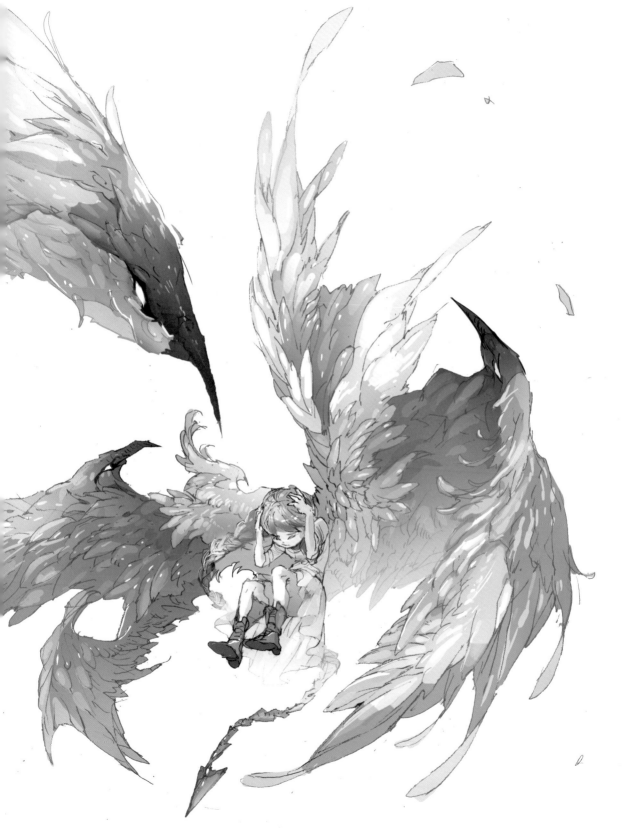

DEMIZUPOSUKA

洞窟の彼女 — Cave girl

風を待つ — Waiting for a gale

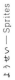

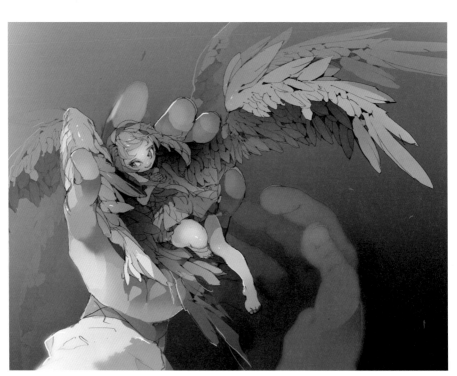

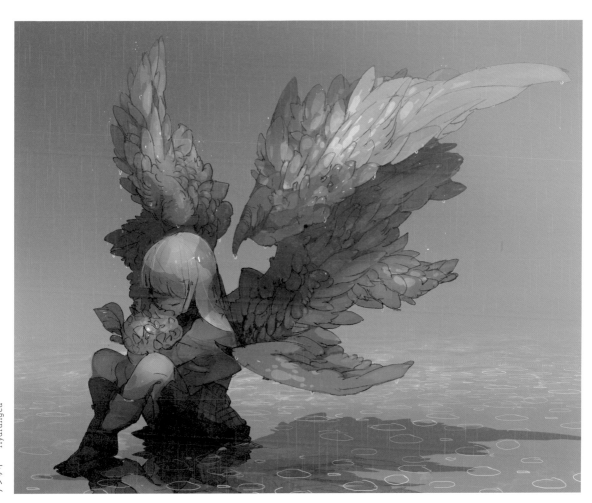

アジサイ — Hydrangea

コンセント
ガール

PONE

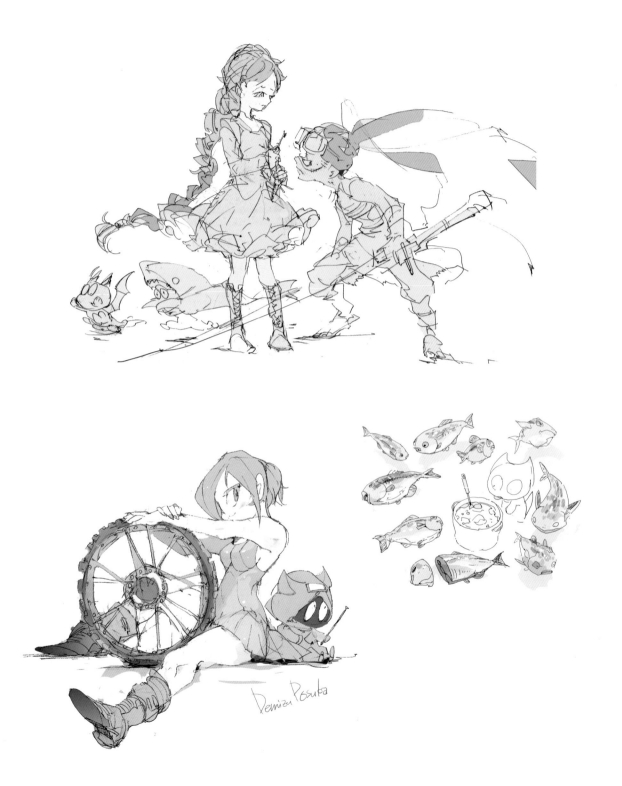

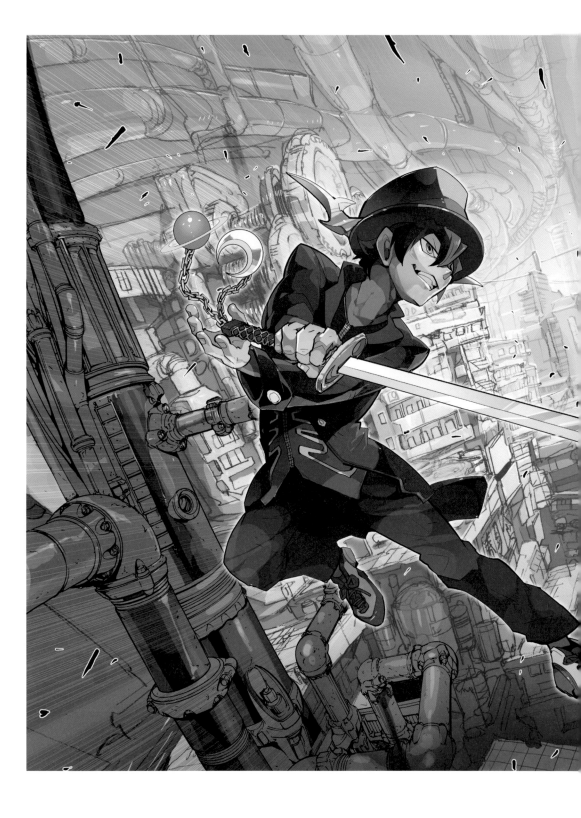

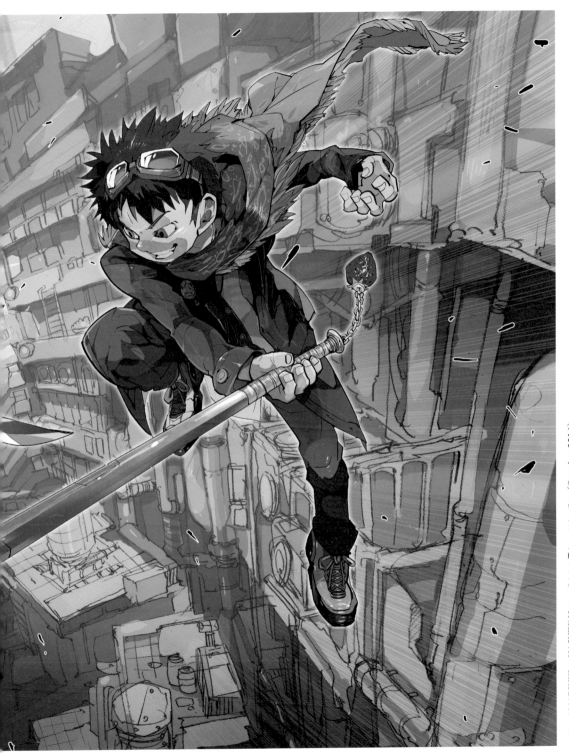

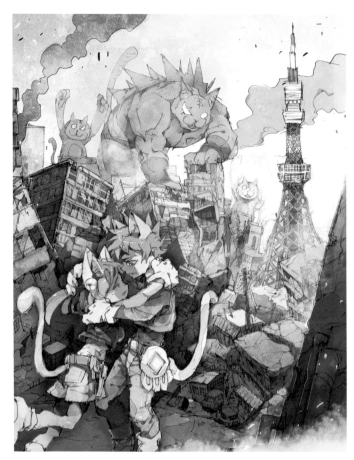

「銀河猫にゃぼろん」© 鴨志田一／アスキー・メディア
ワークス／さくら荘製作委員会 ―
'Ginga neko Nyaboron' © Hajime Kamoshida /
ASCII MEDIA WORKS Inc. / SAKURASOU
Production Committee

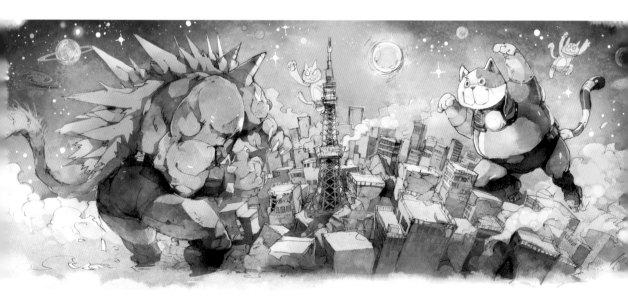

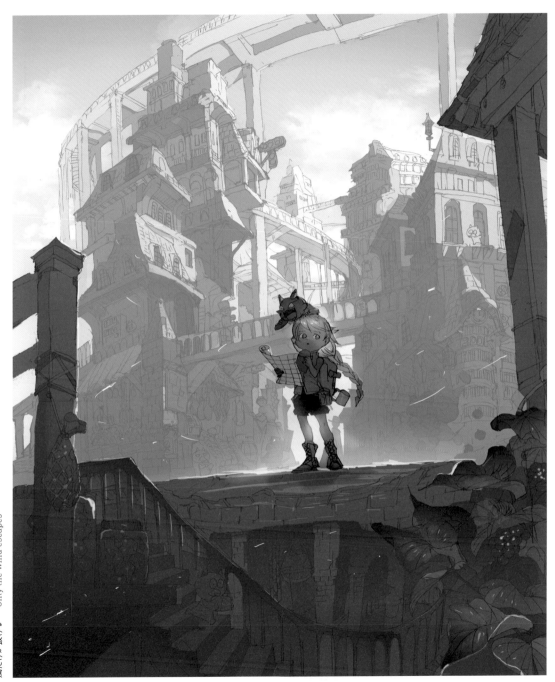

風だけが抜ける ― Only the wind escapes

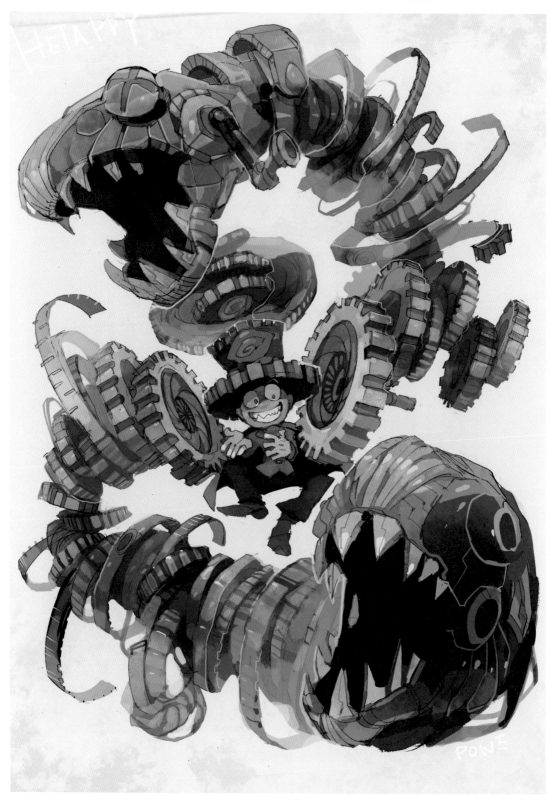

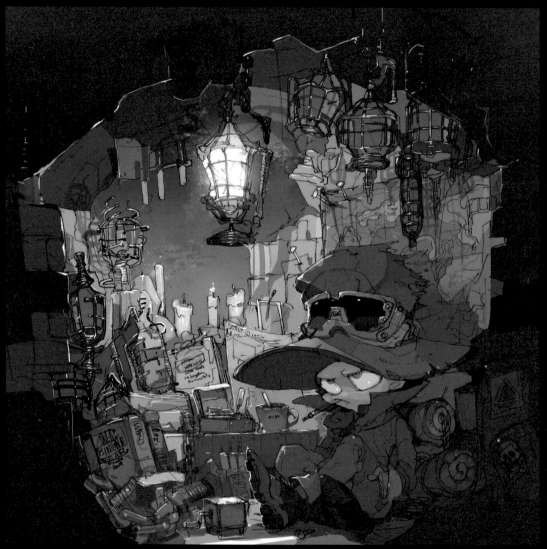

いつか旅に出る ── I'll leave here someday

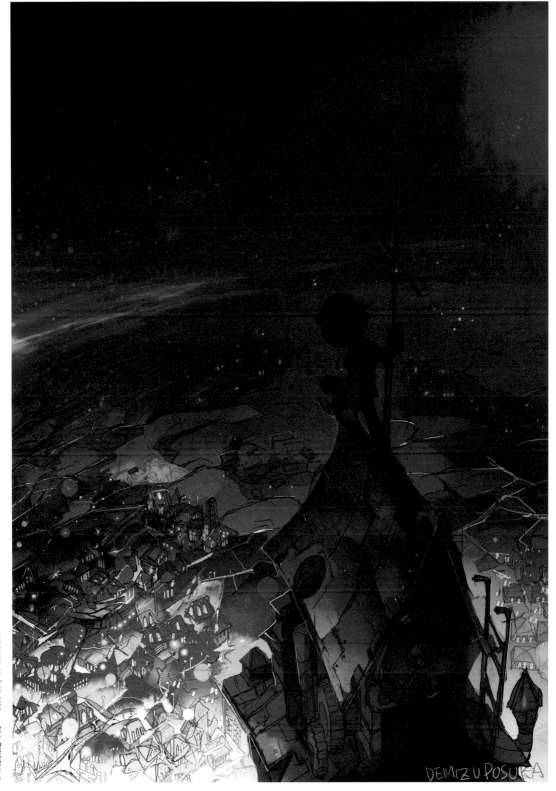

DEMIZU POSUKA

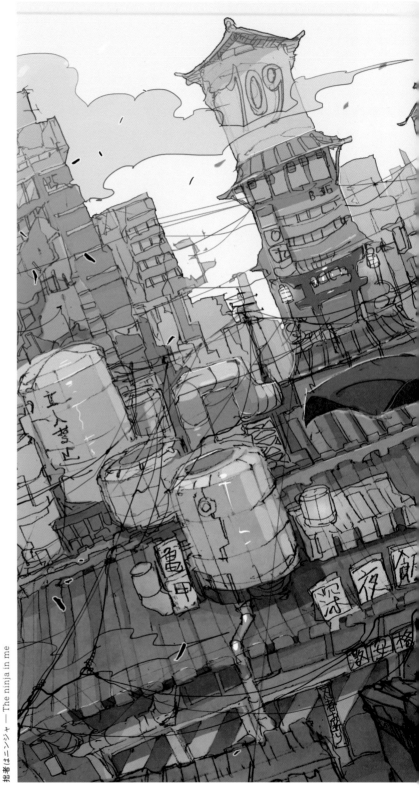

拙者はニンジャ — The ninja in me

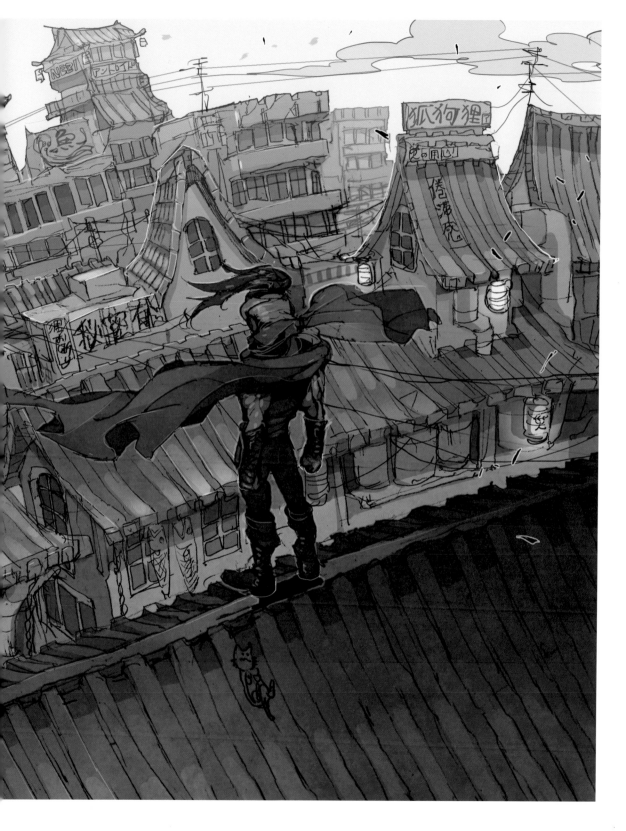

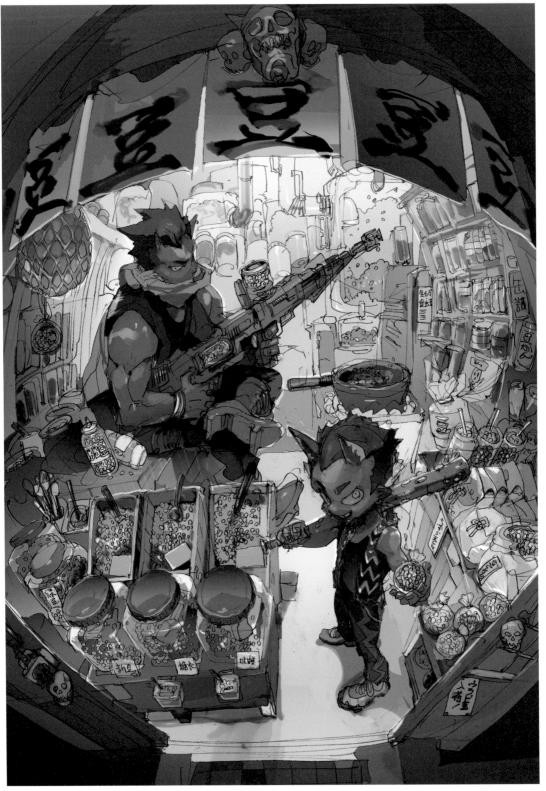

今年もいい豆入ってっるよ！ — Another good year for beans!

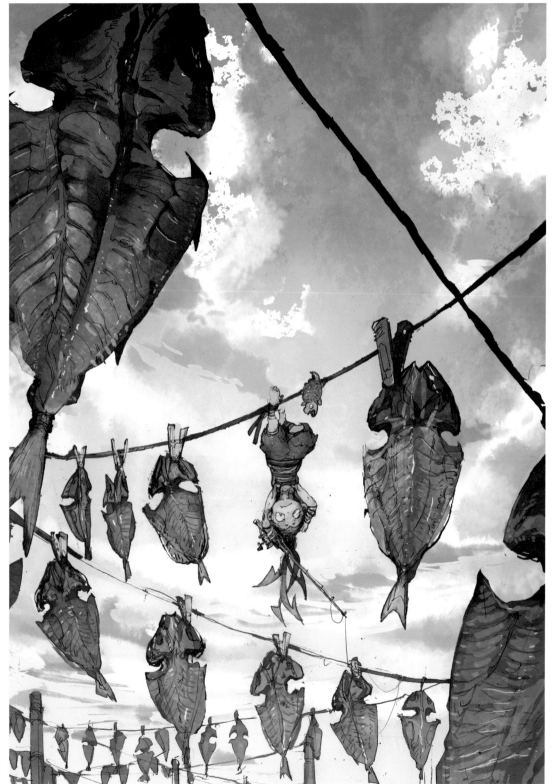

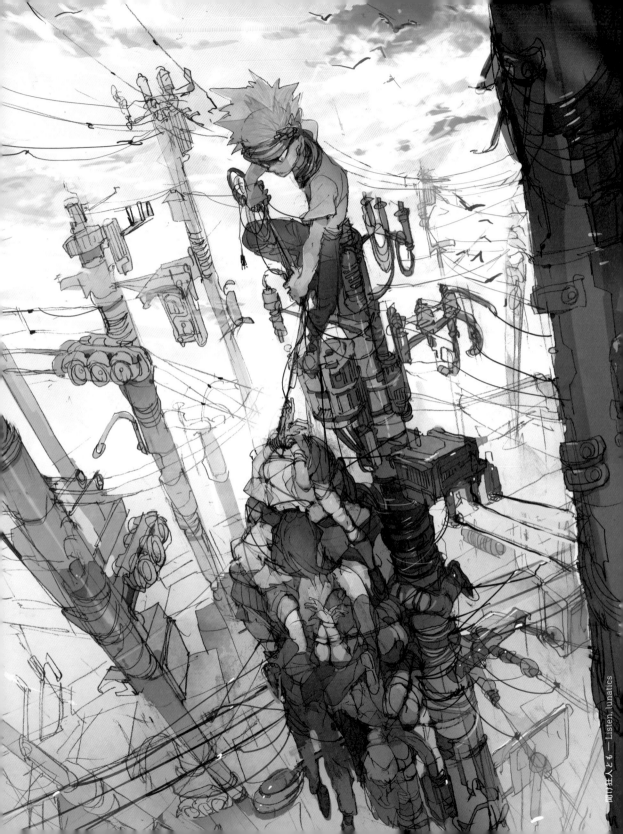

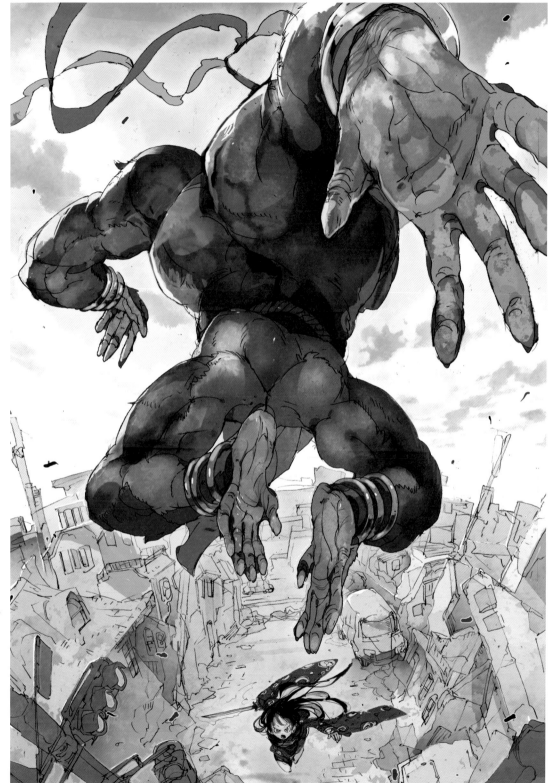

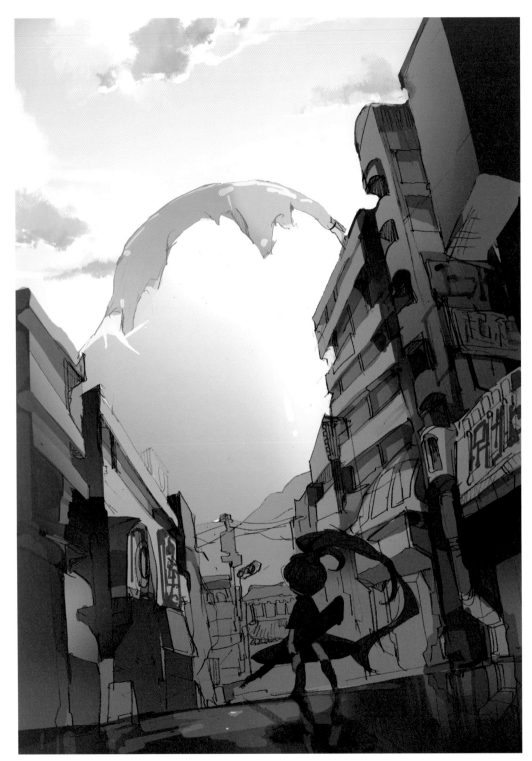

いただきマウンテン —— The sustaining summit

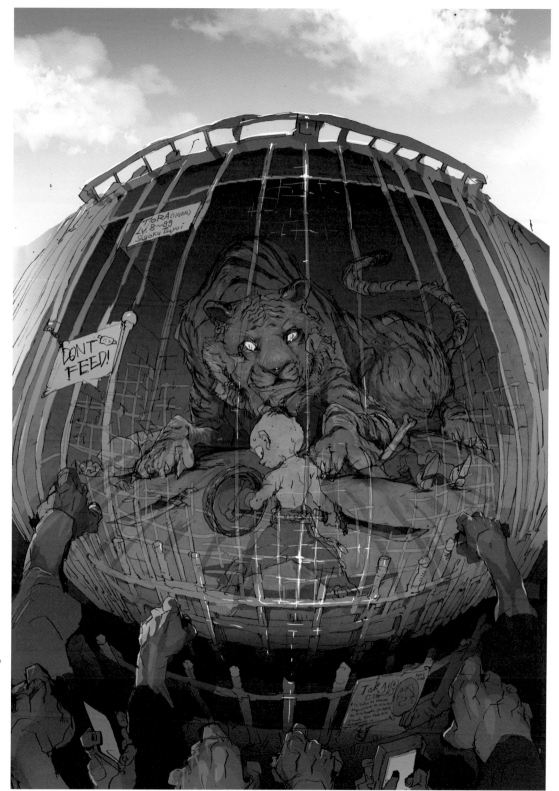

オリの歓声 ― Cheers for the cage

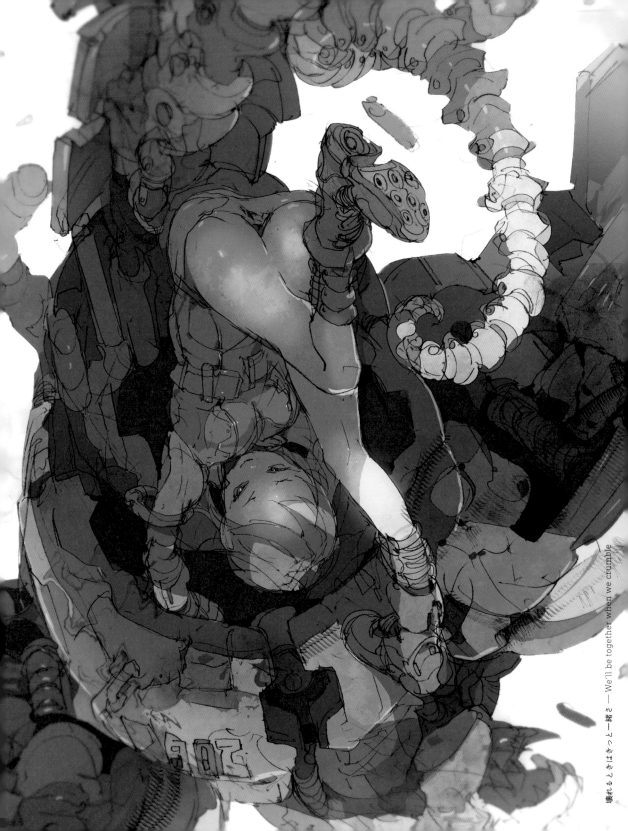

壊れるときはきっと一緒さ — We'll be together when we crumble

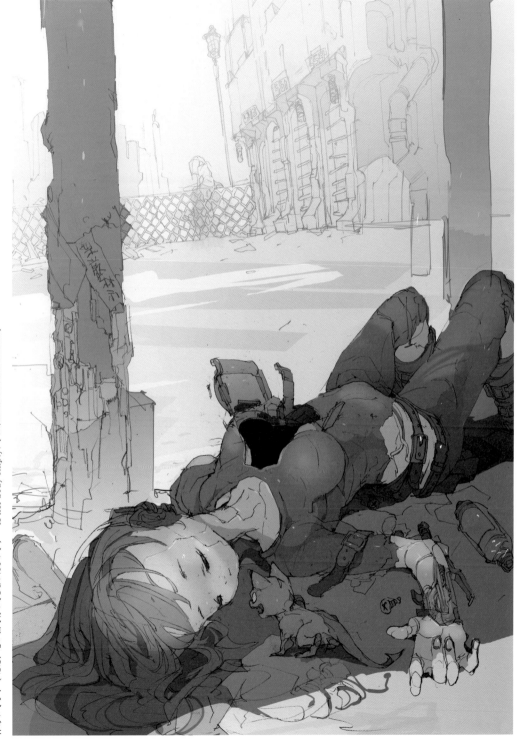

体あいてる？ 〔ええ。心が出て行ってしまったもので〕 ― Is her body empty? 〔 Yes, her heart has been snatched 〕

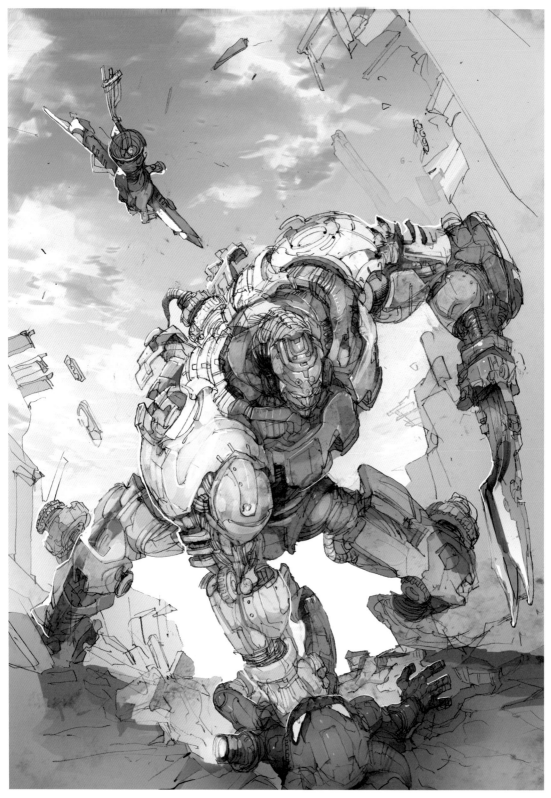

またた — Not yet

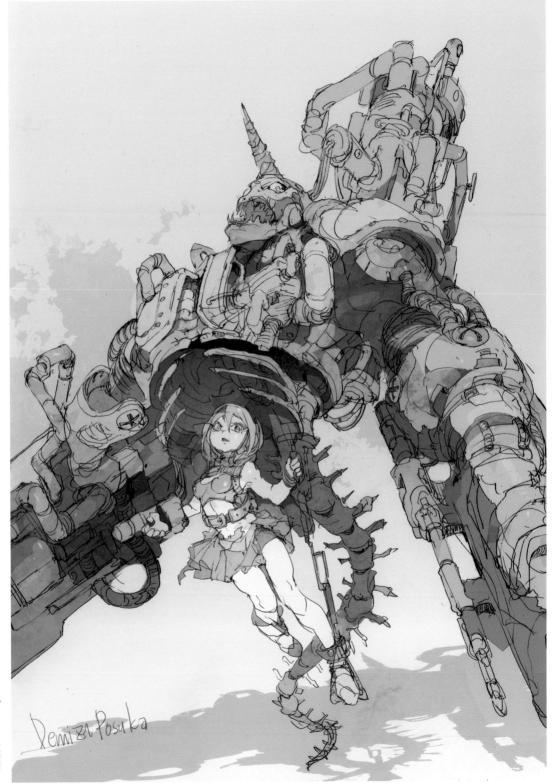

Demizu Posuka

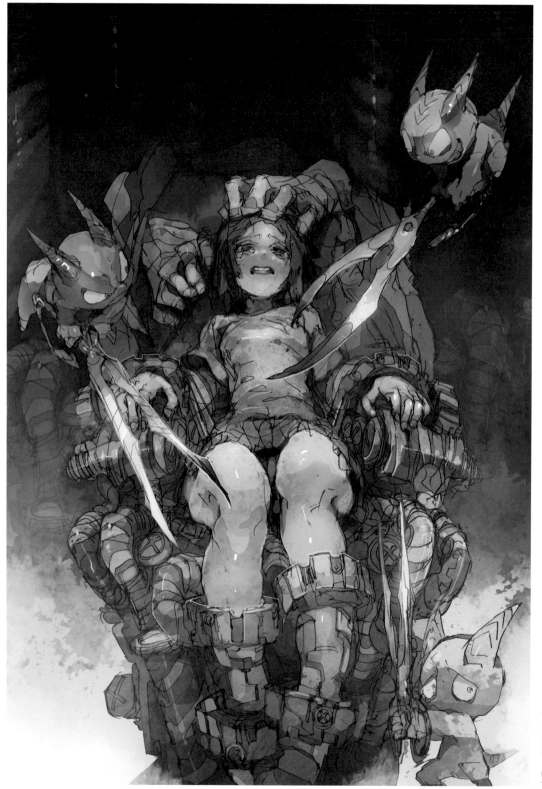

床屋 — At the barber

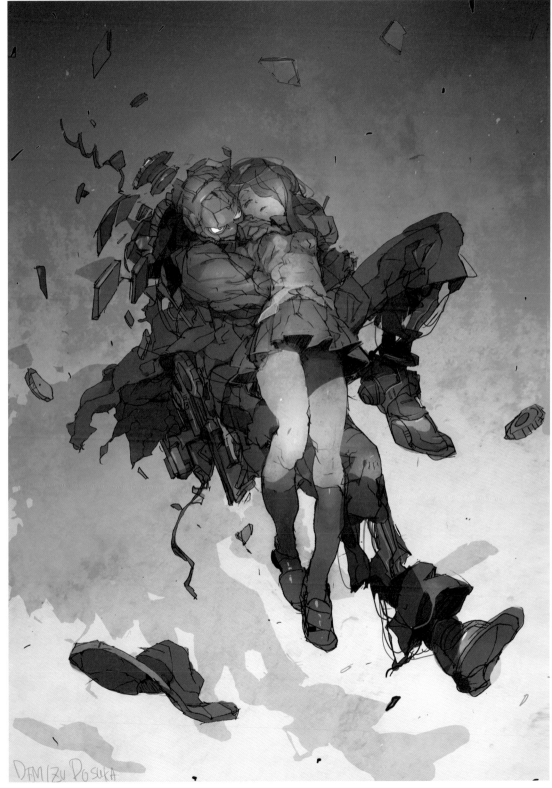

うそつきだね——Liar

DAMIZU ROSUKA

悲しい夢を見ていないなら ― No sad dreams, OK?

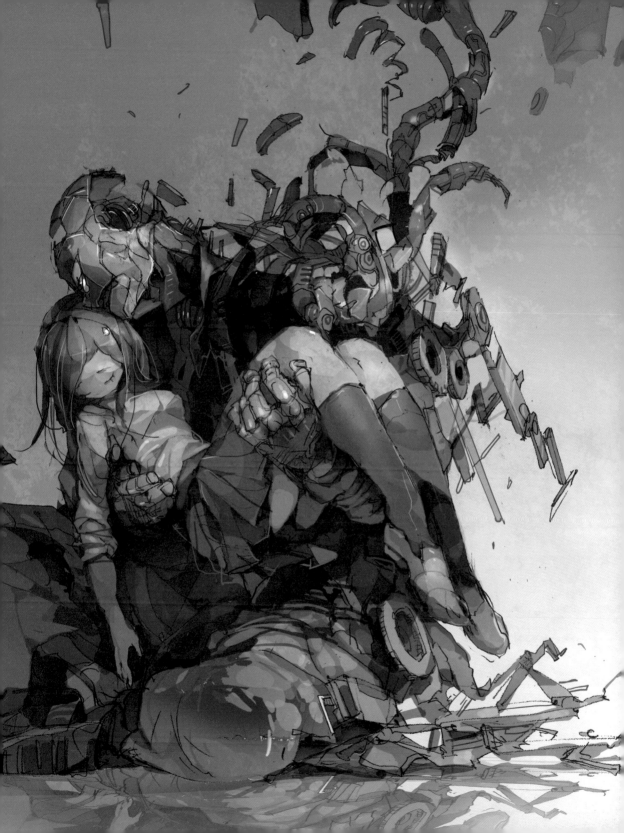

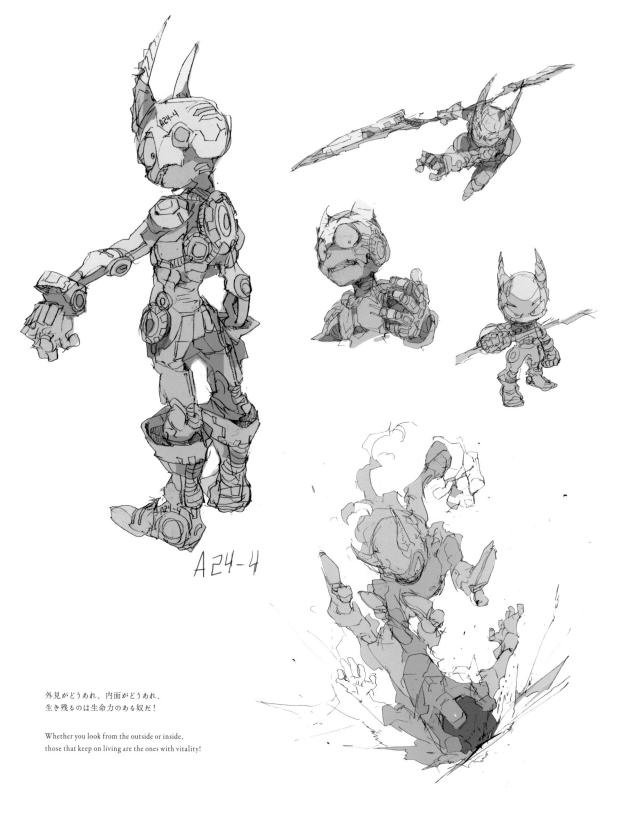

A24-4

外見がどうあれ、内面がどうあれ、
生き残るのは生命力のある奴だ！

Whether you look from the outside or inside,
those that keep on living are the ones with vitality!

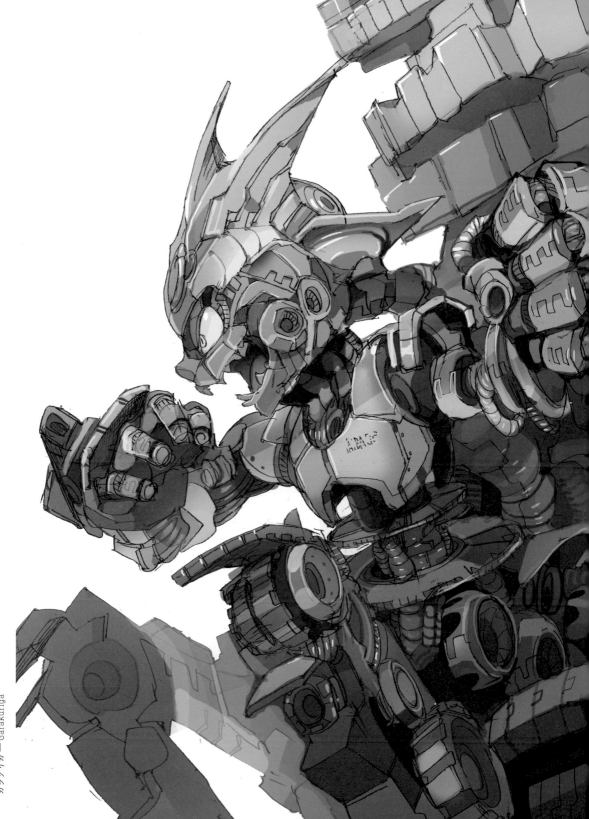

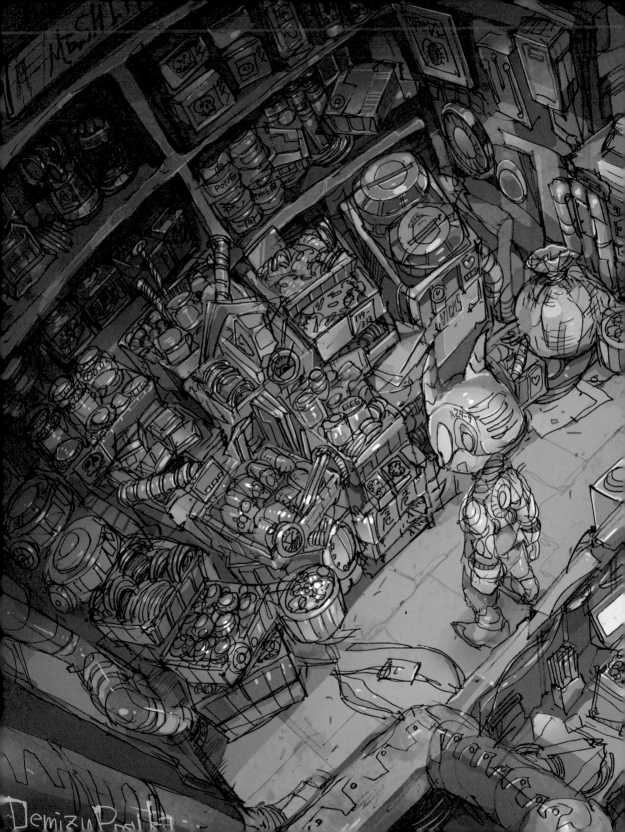

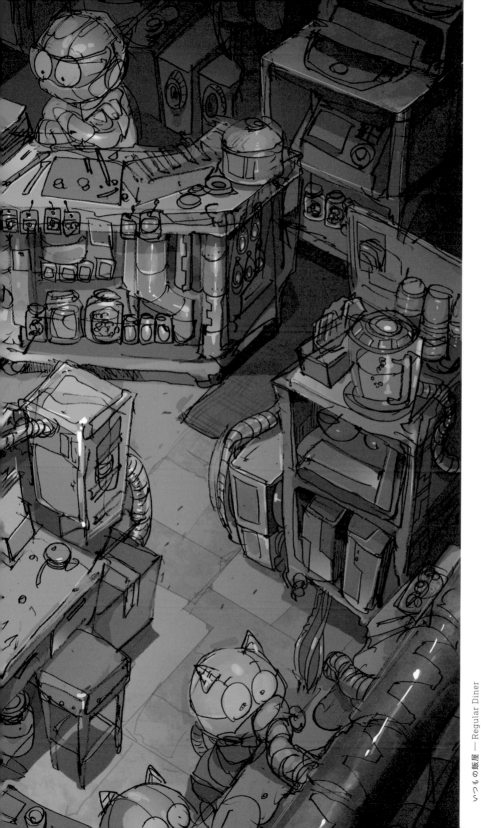

いつもの飯屋 ― Regular Diner

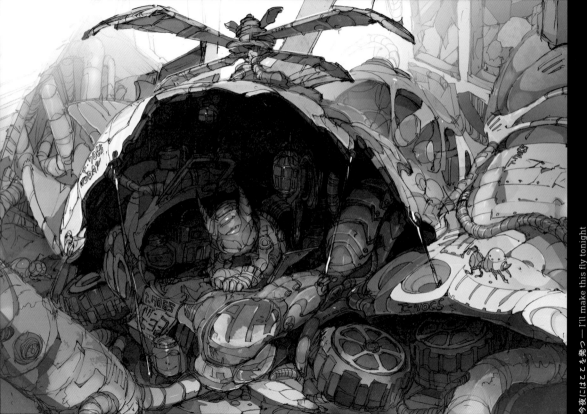

今夜にはここを発つ — I'll make this fly tonight

DeMizuPosuKa

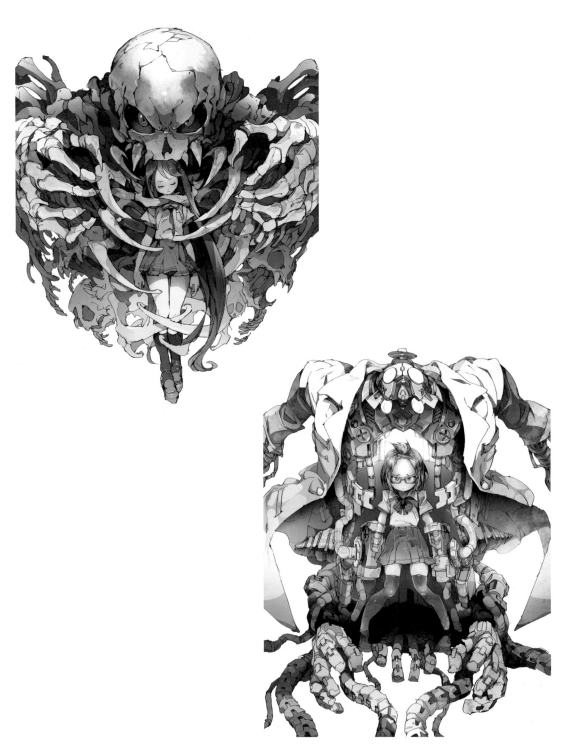

上：ガガガ文庫『キルぐみ』下：『キルぐみ２』カバーイラスト（© 竹内 佑／小学館）
Top: Cover illustration for "KIRUGUMI" from GAGAGA BUNKO
Bottom: Cover illustration for "KIRUGUMI 2" from GAGAGA BUNKO (© YU TAKEUCHI / SHOGAKUKAN Inc.)

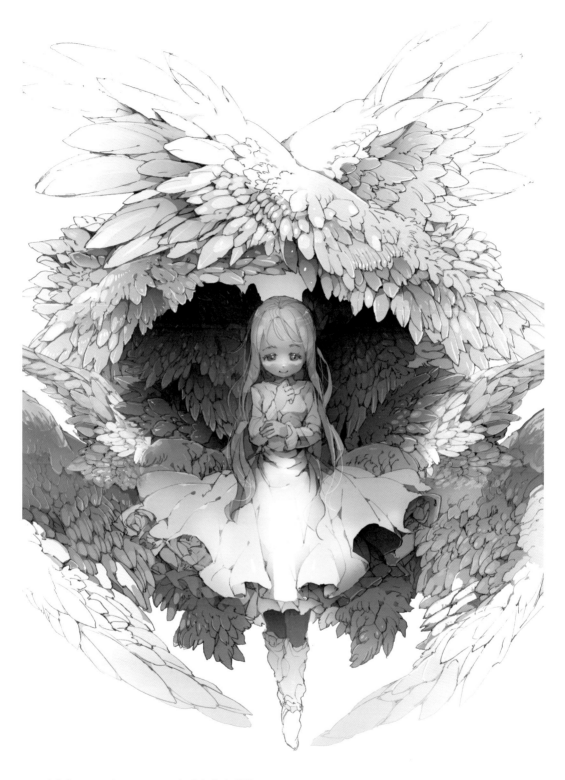

ガガガ文庫『キルぐみ3』カバーイラスト（© 竹内 佑／小学館）
Cover illustration for "KIRUGUMI 3" from GAGAGA BUNKO (© YU TAKEUCHI / SHOGAKUKAN Inc.)

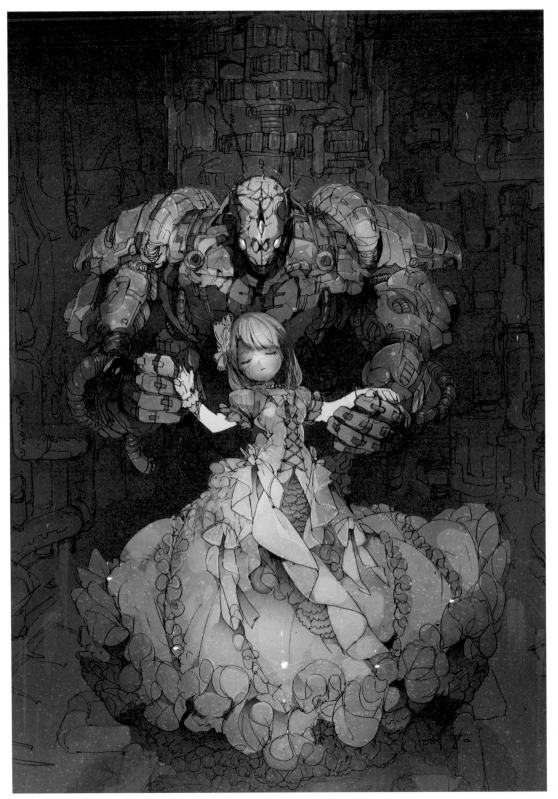

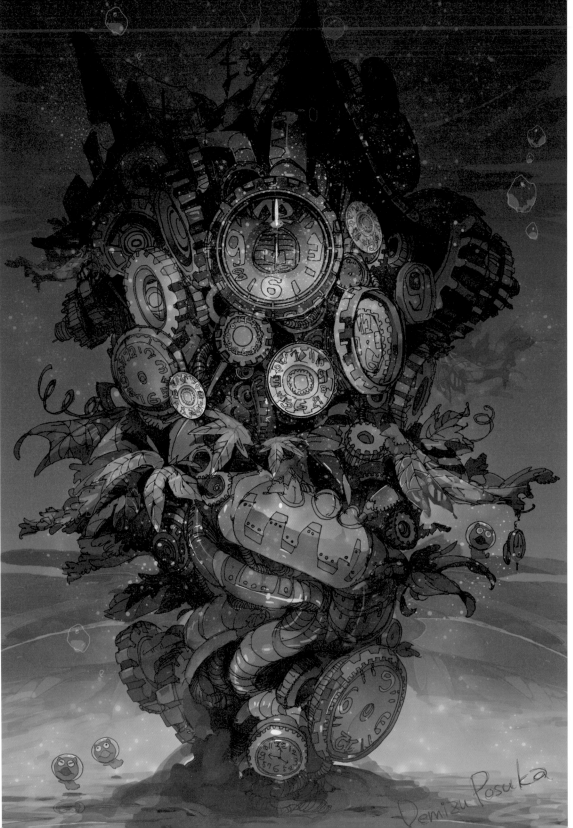

時計塔下の待ち合わせ — Rendezvous under the clock tower

Demizu Posuka

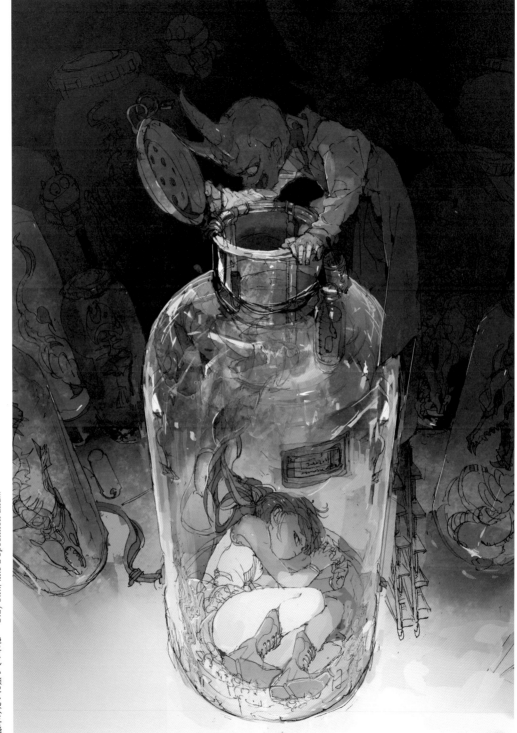

標本みたいに黙っていれば ── Stay still, like a specimen and...

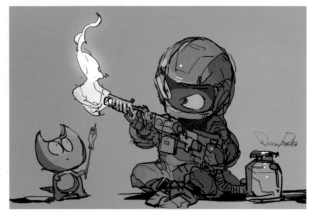

挨拶に深い意味があると思うな！
ただお前と仲良くしたいだけだ！

Don't think there is any meaning to my greetings!
I just want to be your friend!

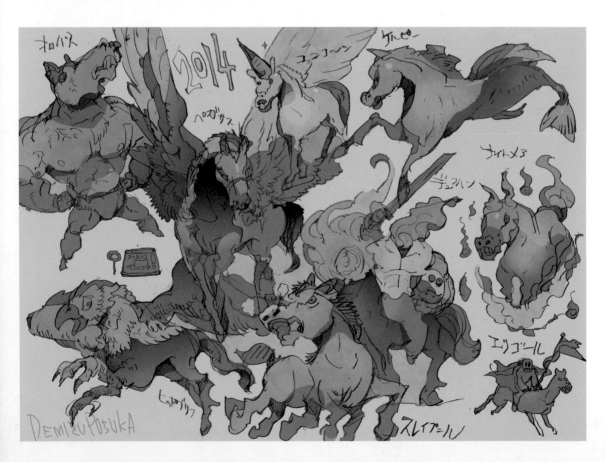

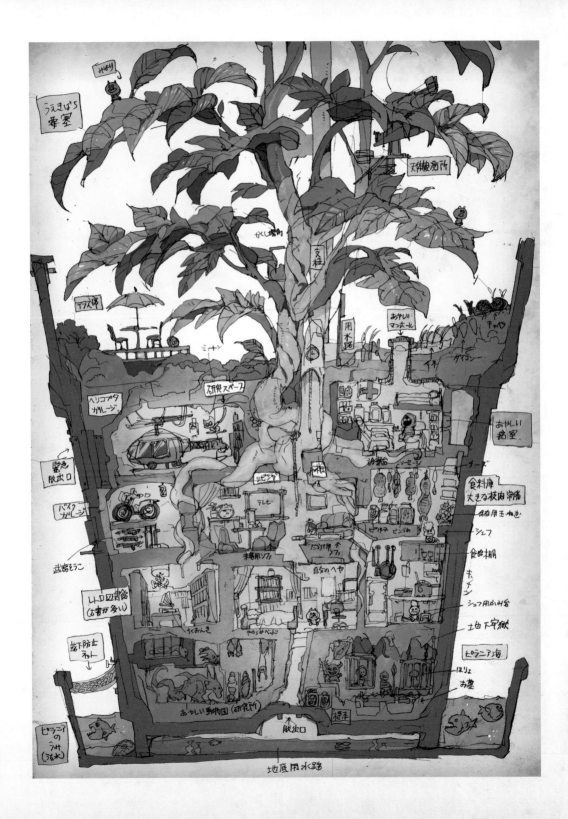

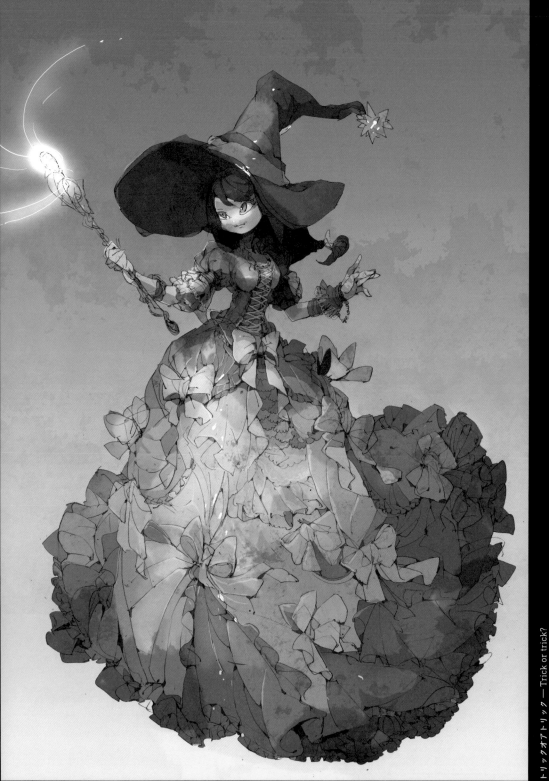

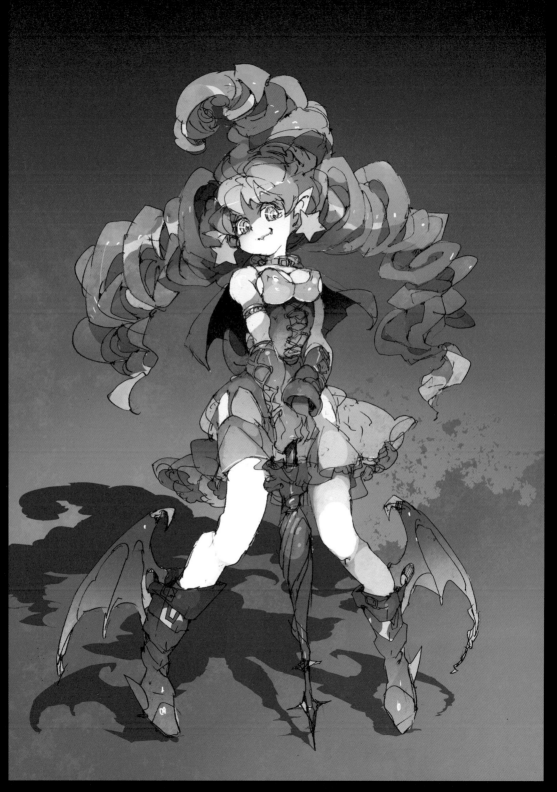

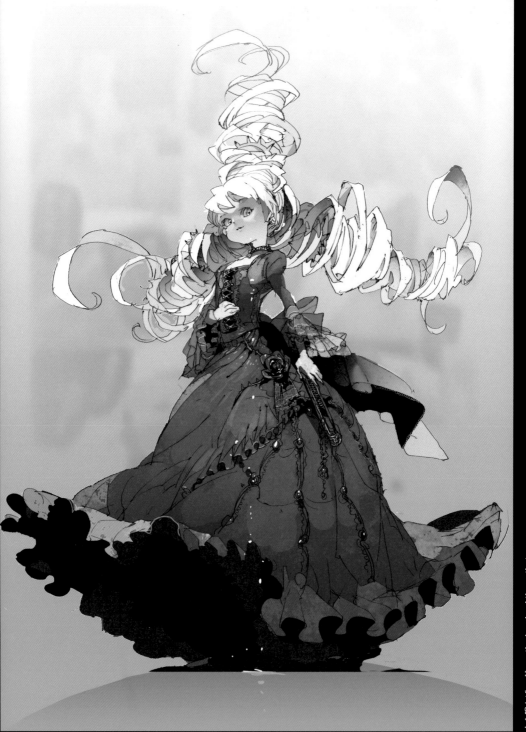

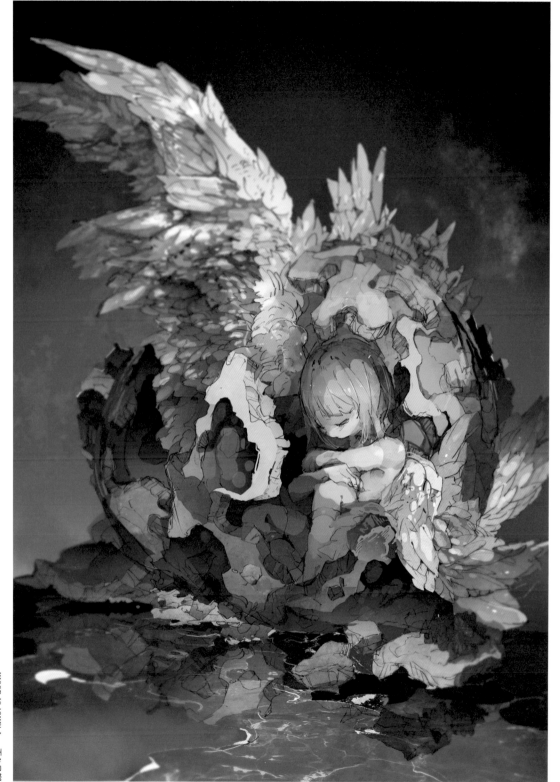

滅亡の星 — Planet of doom

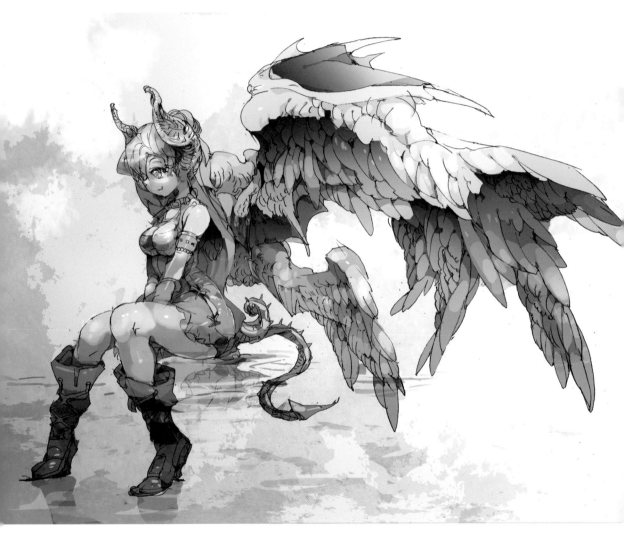

仮装ちゃん ─ Miss Dress-up

Demizu Posuka

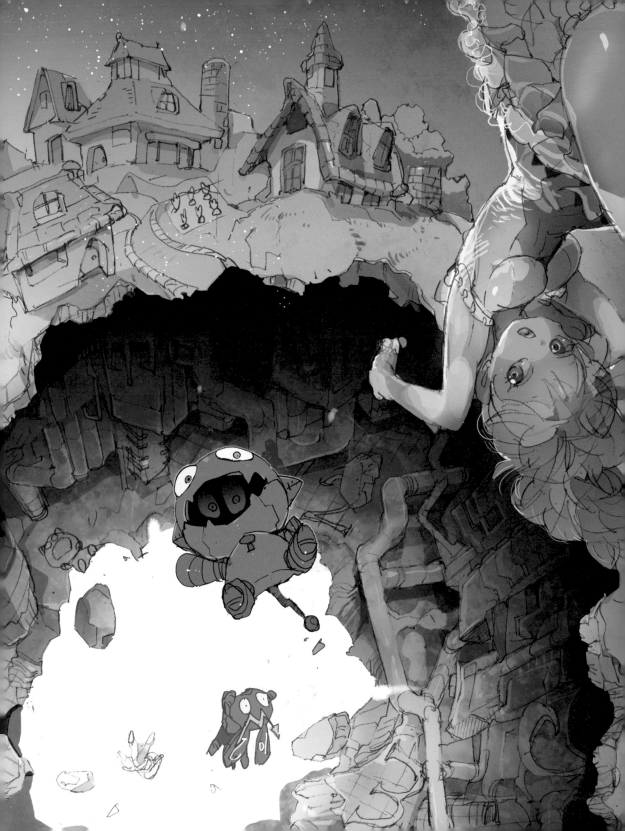

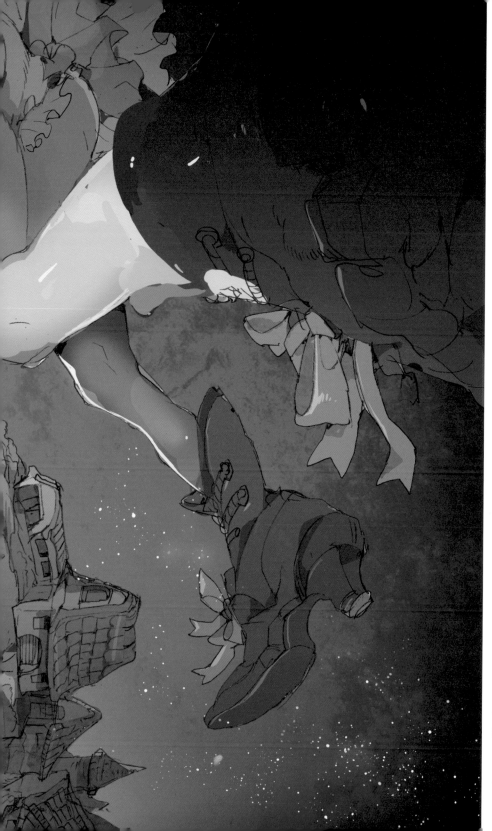

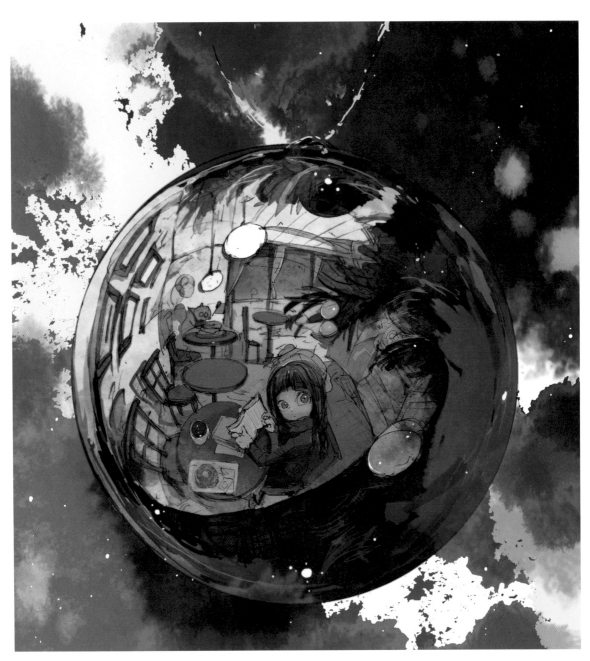

merry

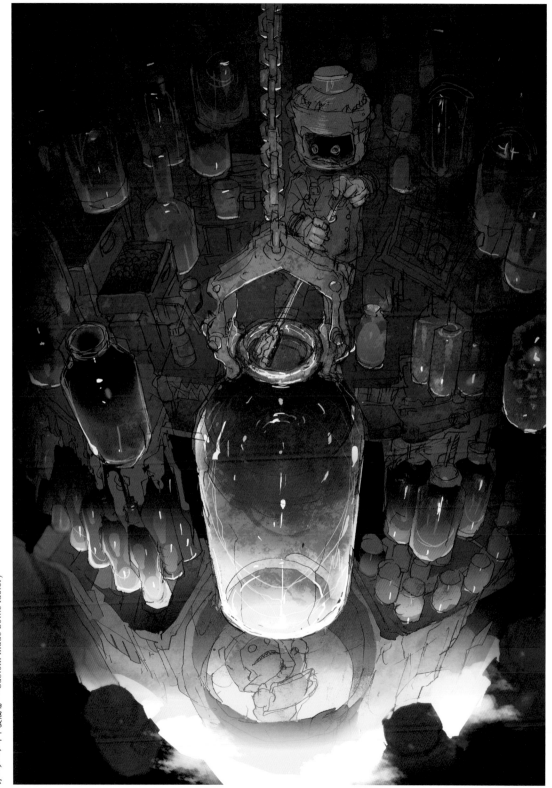

オーダーメイド製瓶場 — Custom made bottle factory

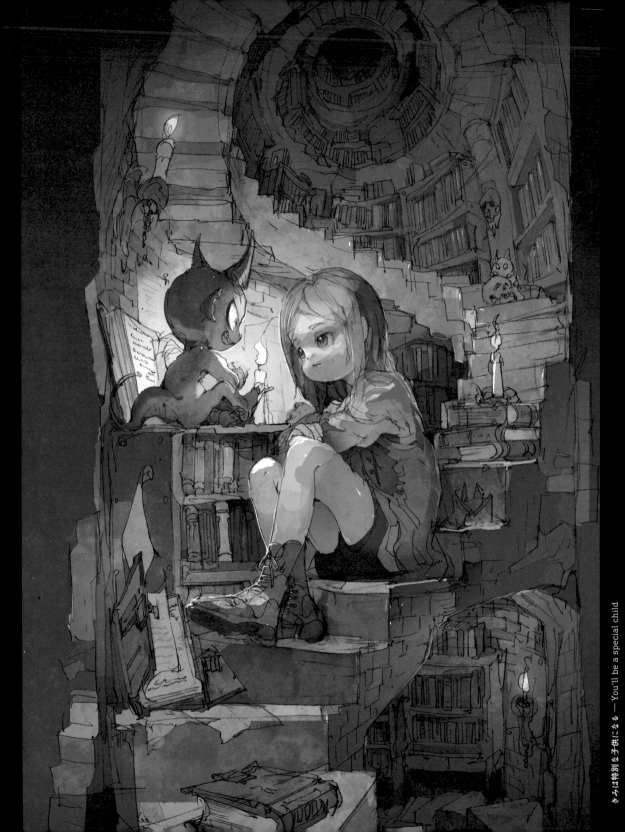

きみは特別な子供になる — You'll be a special child

何年前に遡る気だ — Feels like several years back

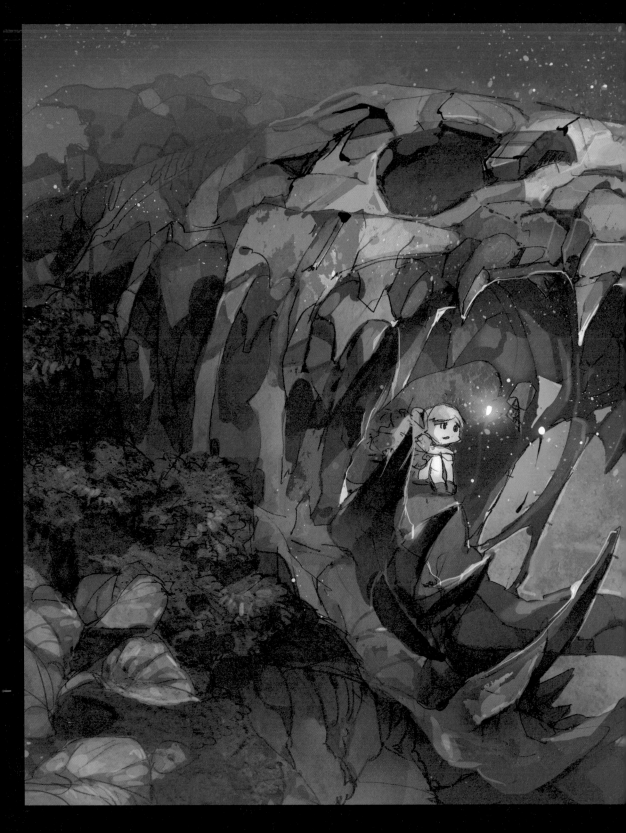

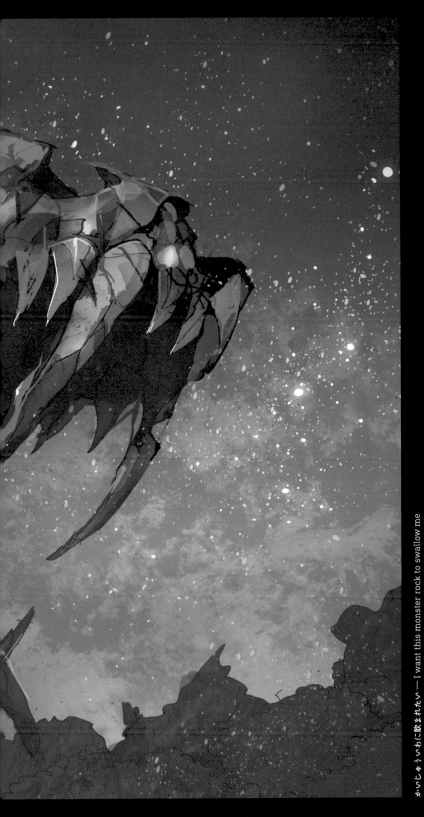

かいじゅうにわにのまれたい —— I want this monster rock to swallow me

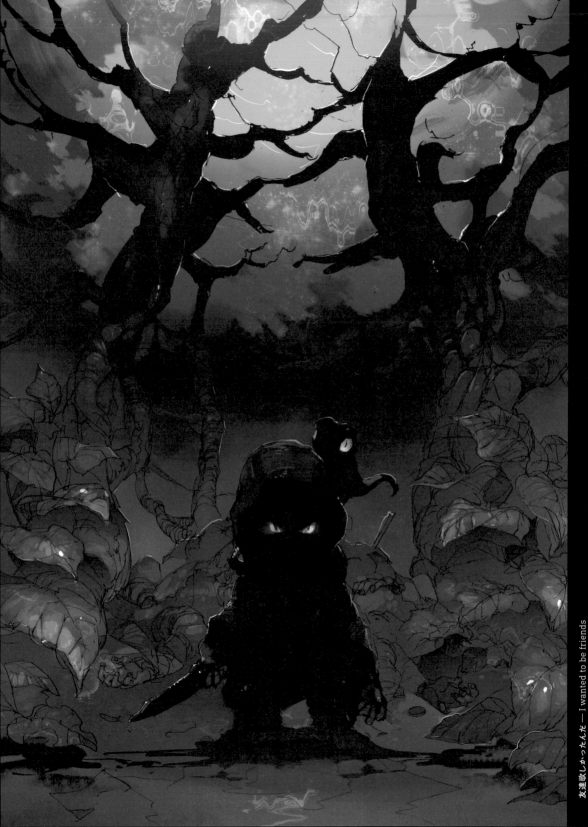

友達欲しかったんだ — I wanted to be friends

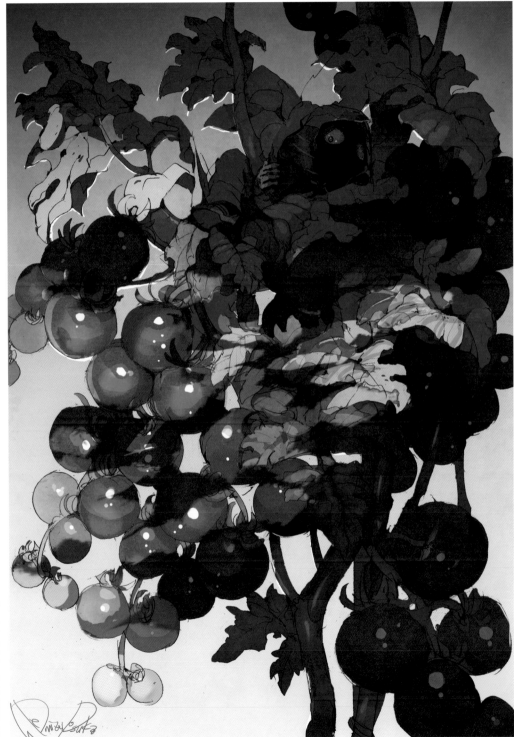

あいつは見ている ── He's watching

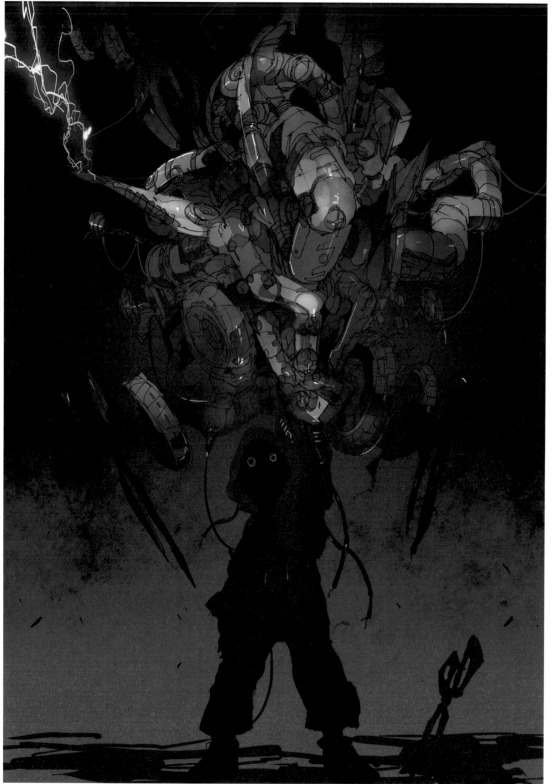

ENCROACHMENT

メリィ X-day〔贈り物をもらえるのは〔良い子〕じゃない、愛されている子供だけなんだ〕— Merry X-day〔Only my beloved bad child gets a present〕

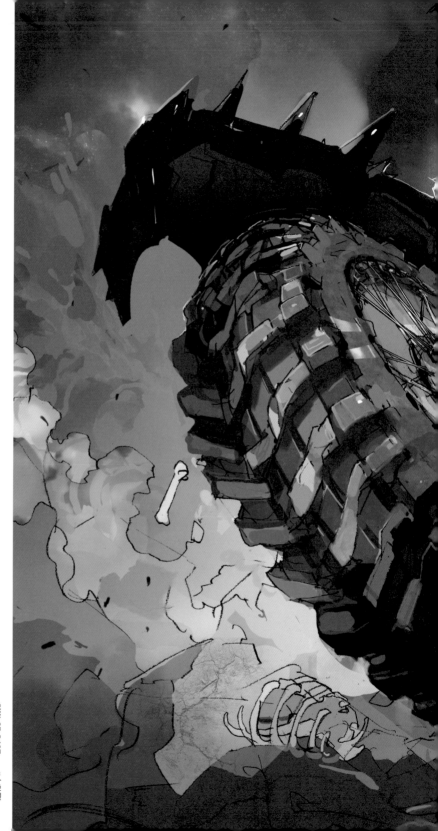

遊ぼうか —— Let's do this

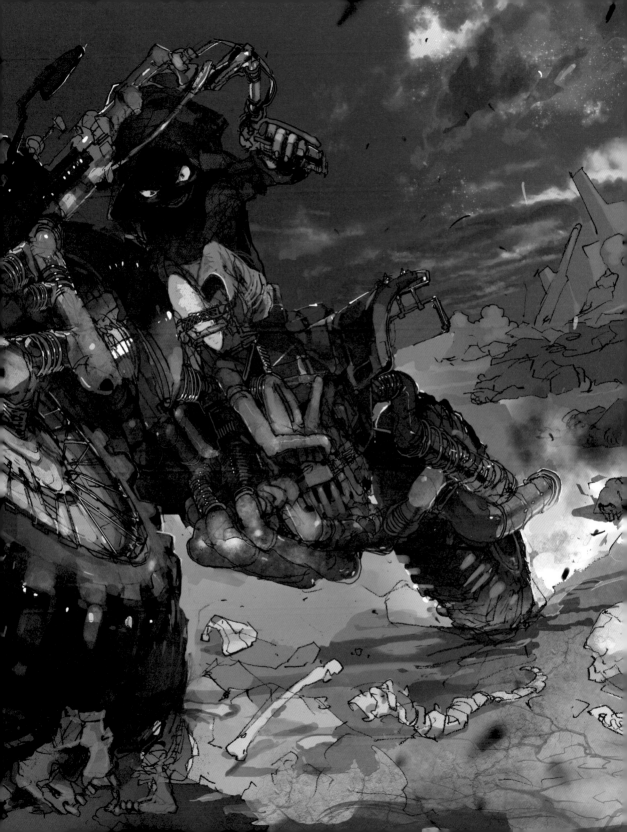

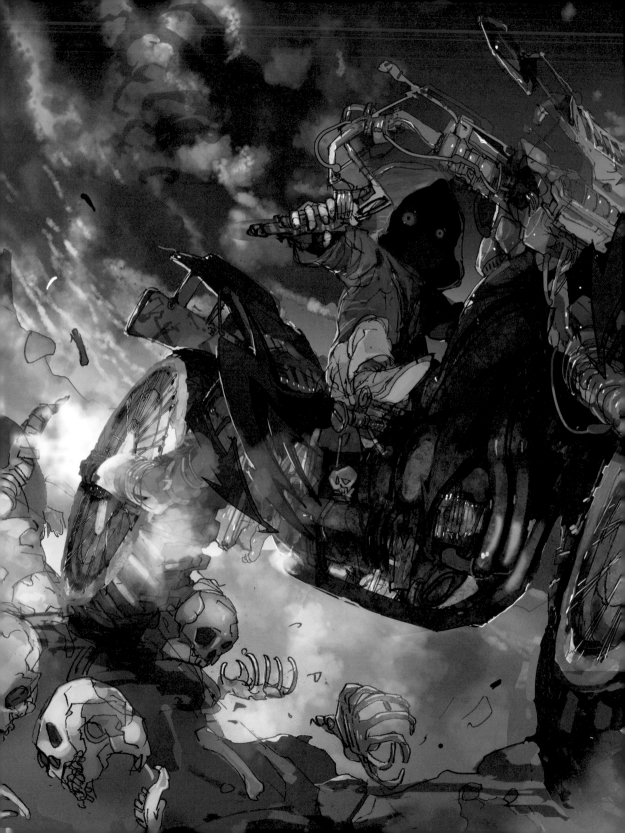

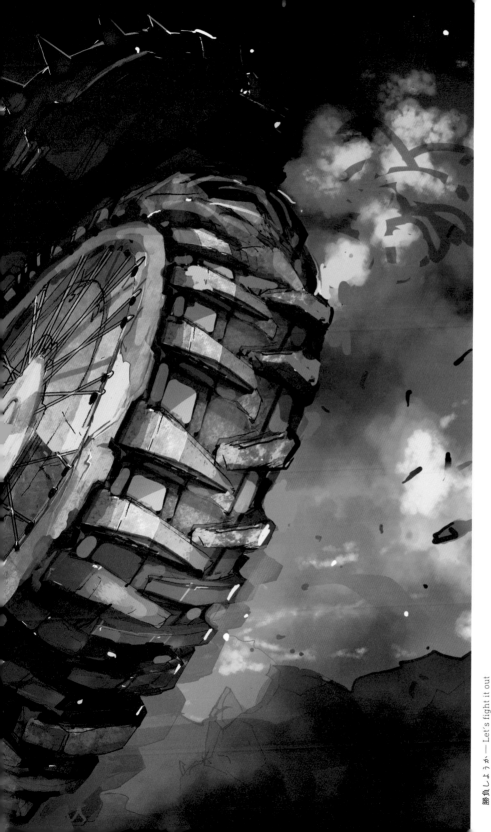

勝負しようか── Let's fight it out

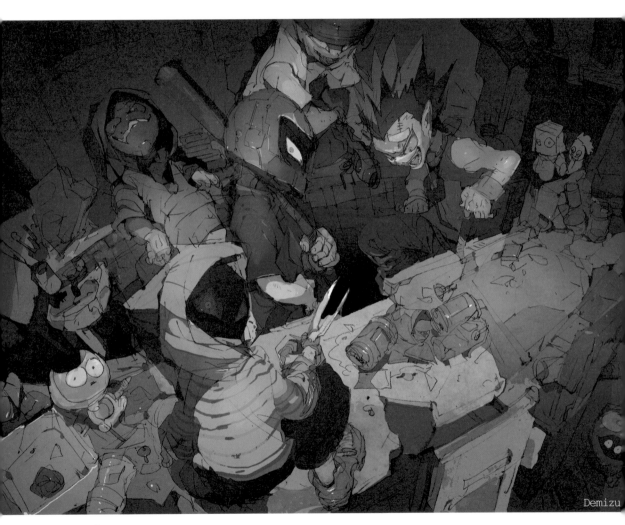

カウンター —— Counter

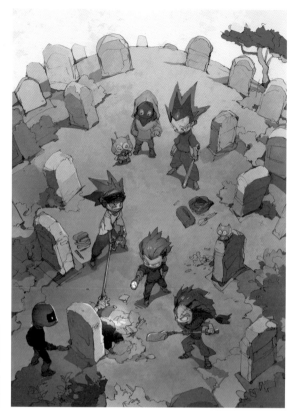

悪あガキ — Fruitless

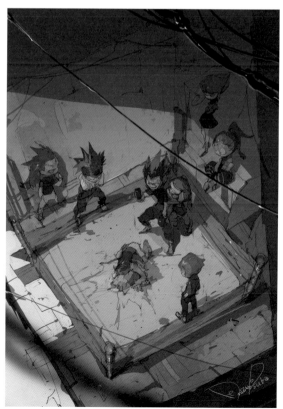

対抗者 — Rivals

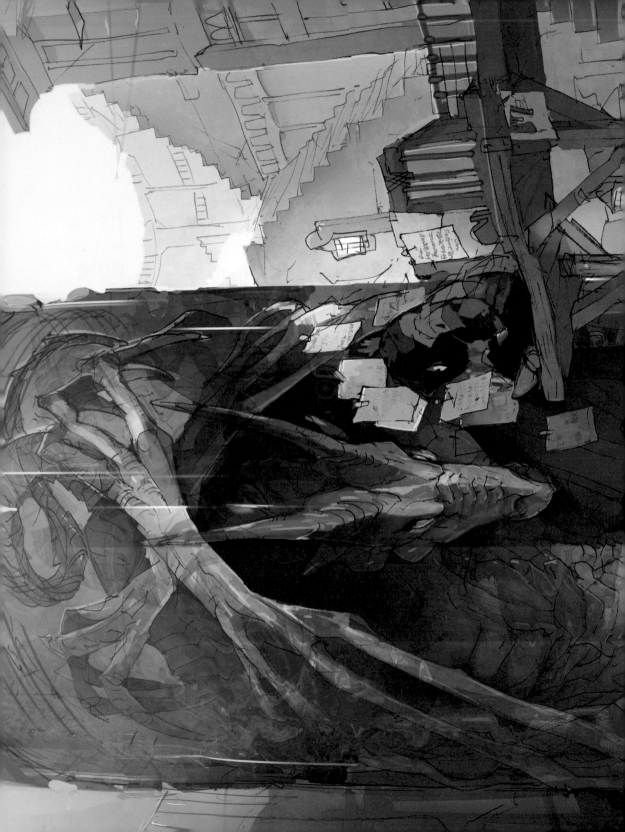

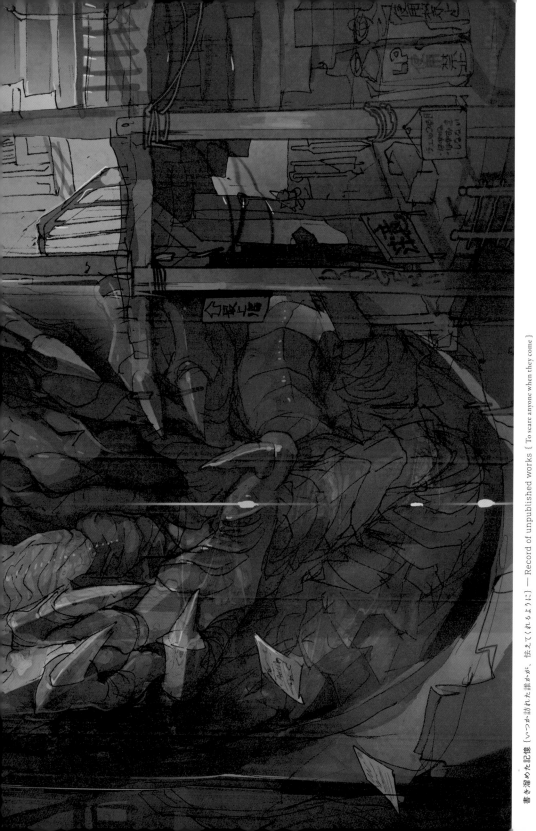

書き溜めた記憶（いつか訪れた誰かが、怖えてくれるように）— Record of unpublished works 〔 To scare anyone when they come 〕

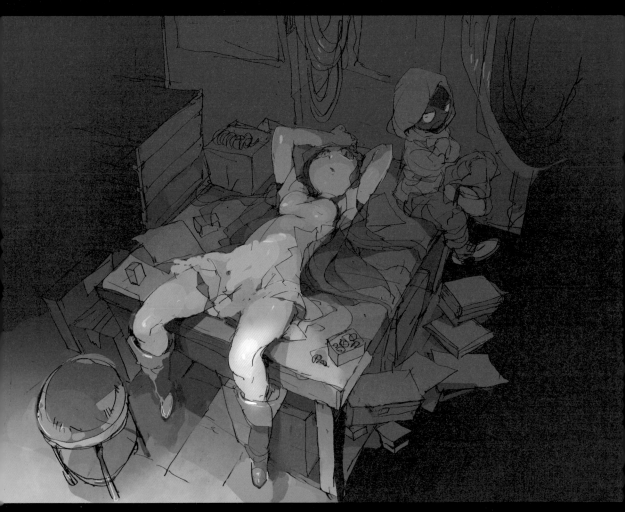

工場机と退屈少女 ― Factory desk and a bored girl

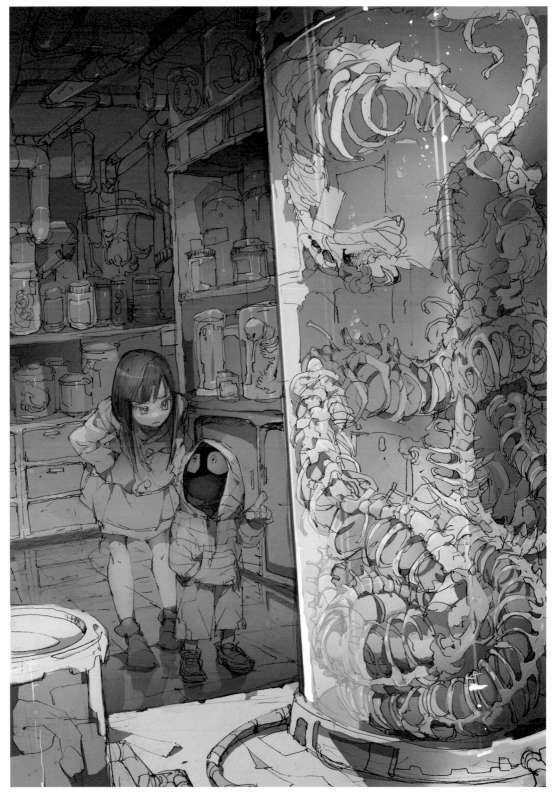

怪訝な顔をして ― A dubious look

スキ〜だ〜！ ― I love― you―!

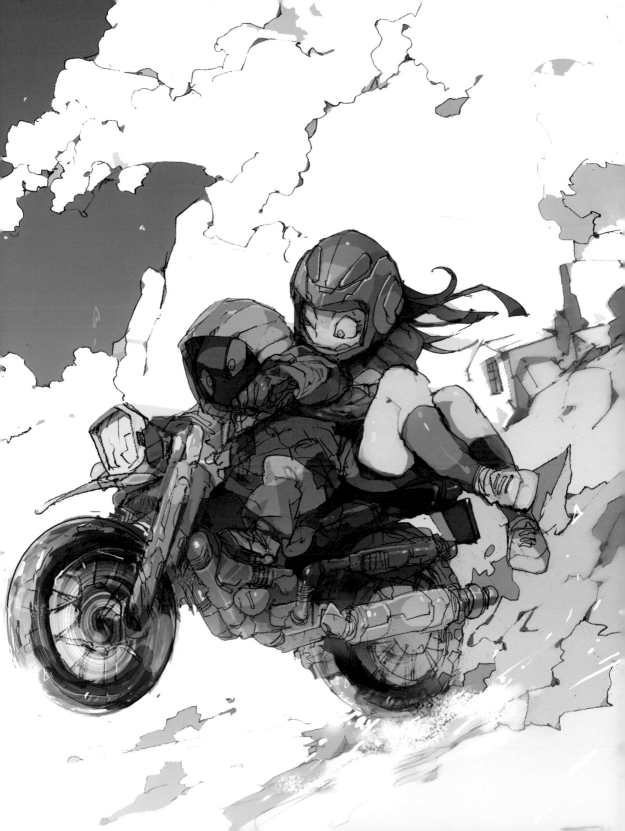

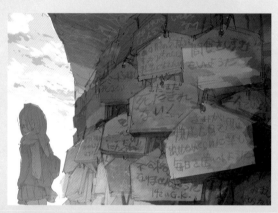

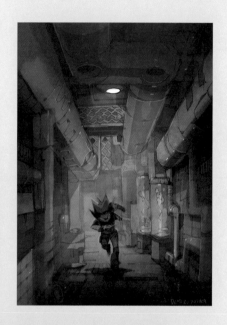

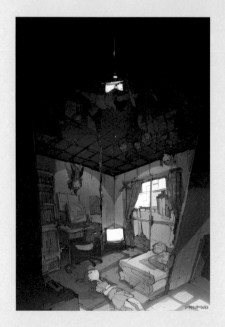

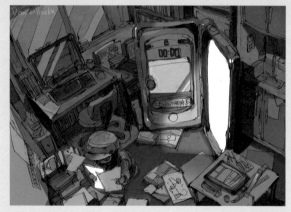

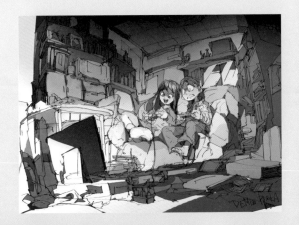

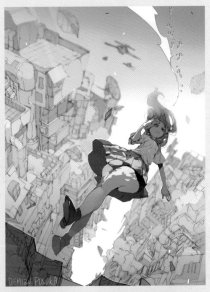

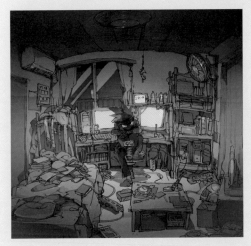

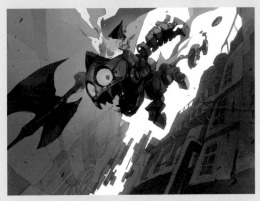

取り立てて書くことはございません。
だって今日、恐ろしいことは
何ひとつ起きなかったのですから！

I didn't write anything in particular.
Because today nothing frightful happened at all!

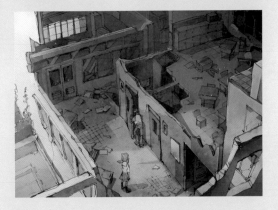

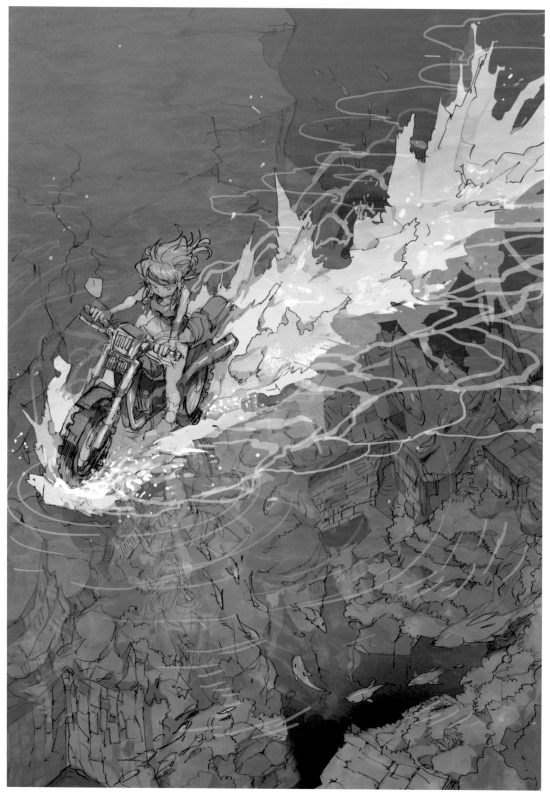

海面ライダー —— Ocean rider

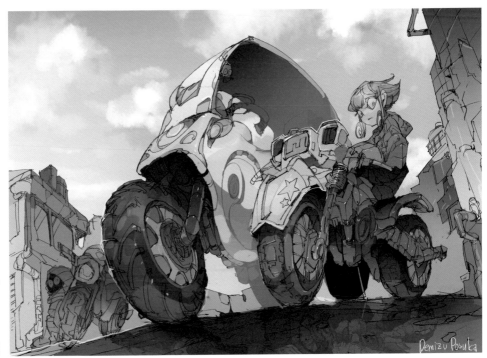

Demizu Posuka

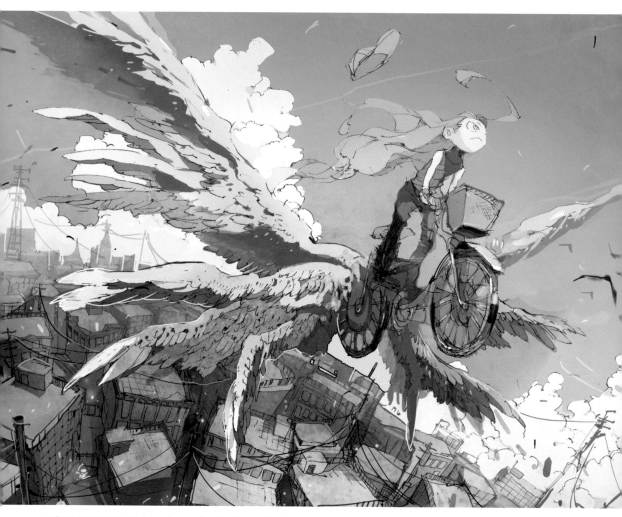

二度とこんな街に戻るものかと ― I never thought I'd see this place again

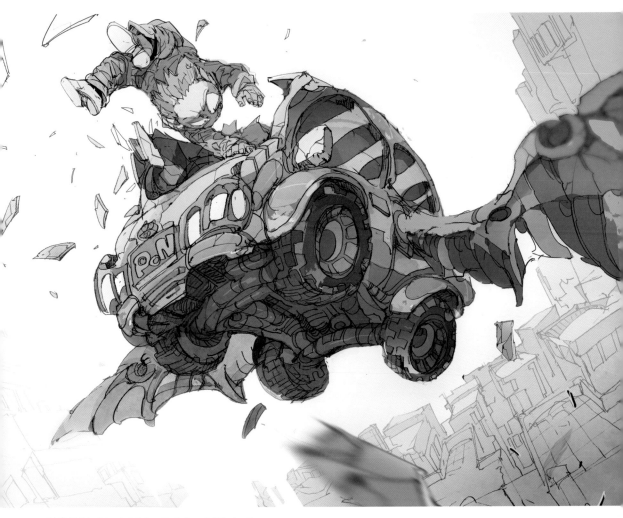

また駄目だ！ くそったれめ！ ― Foiled again! Bastard!

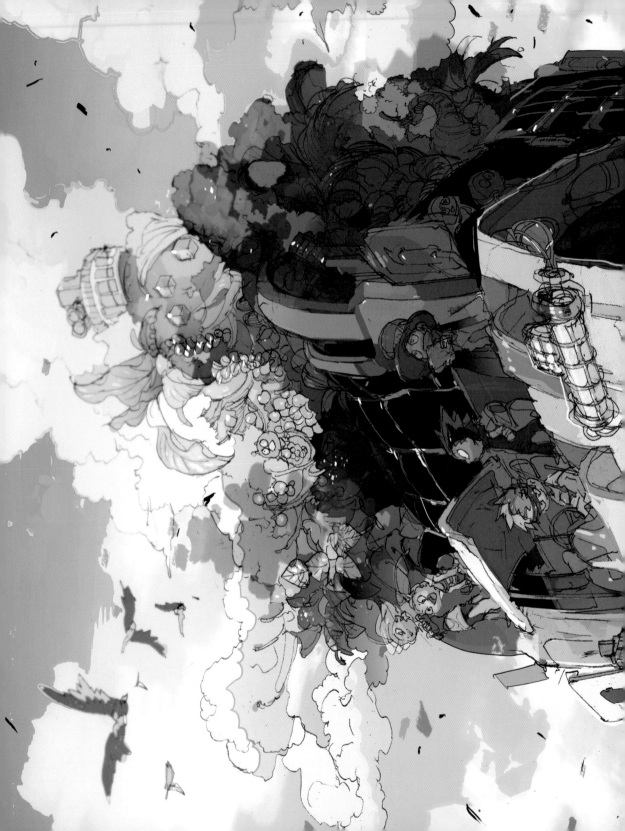

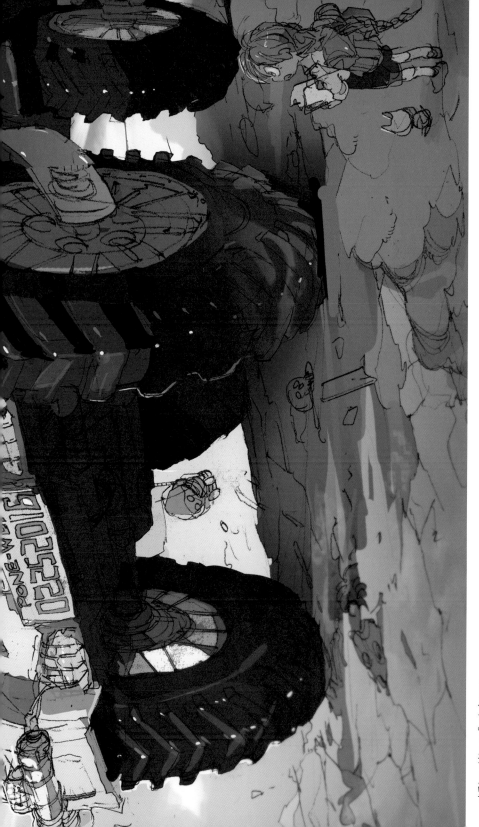

オアシス・バギー —— Oasis buggy

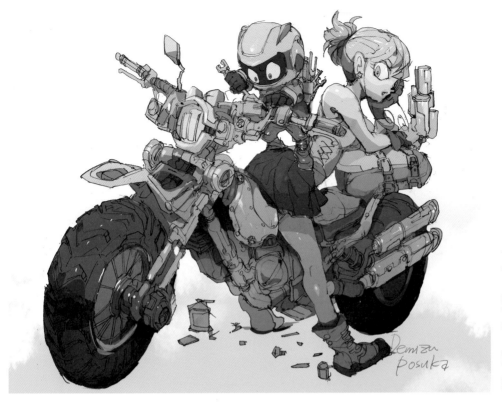

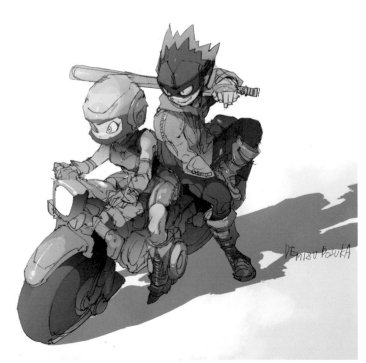

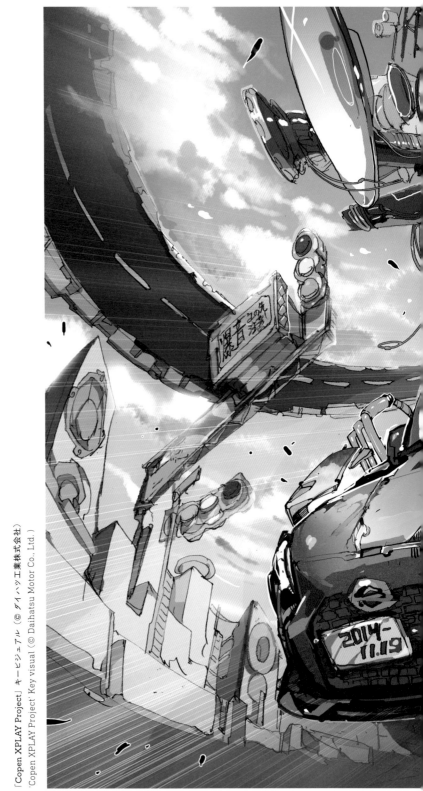

爆音ひの先へ法彌

2014-11.19

「Copen XPLAY Project」キービジュアル（© ダイハツ工業株式会社）
'Copen XPLAY Project' Key visual（© Daihatsu Motor Co., Ltd.）

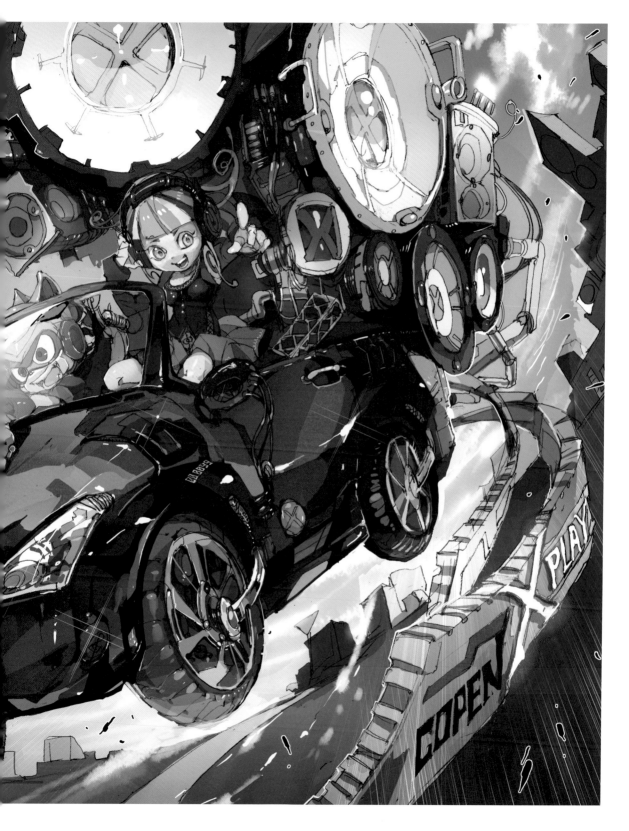

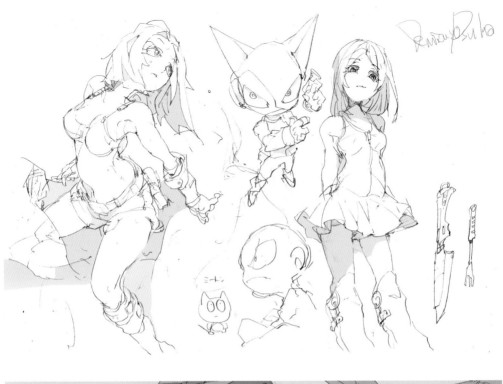

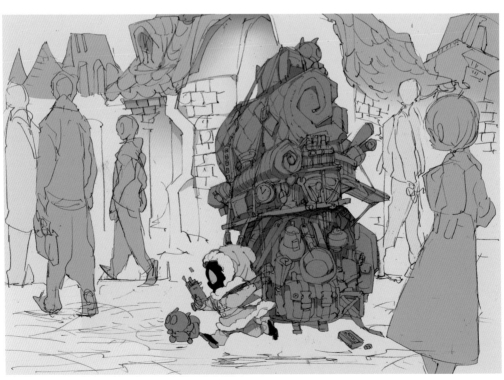

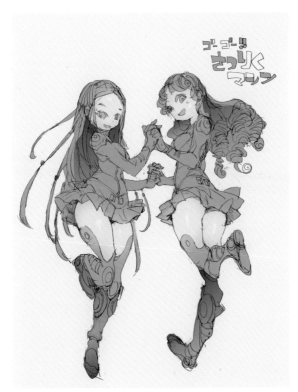

ゴーゴー!!
さつりく
マシソ

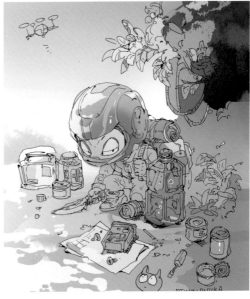

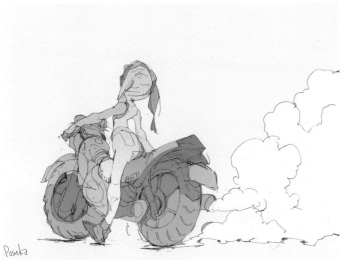

Posuka

線をたくさん描くことは、
塗りわける部分が増えるということで、
つまり「それを長く楽しめる」というメリットがあります。
長く楽しみたいから、たくさん線を描きます。

Drawing many lines creates
many separate colored parts – in other words,
lines give you more to enjoy.
I want to enjoy drawings for a long time,
so I draw many lines.

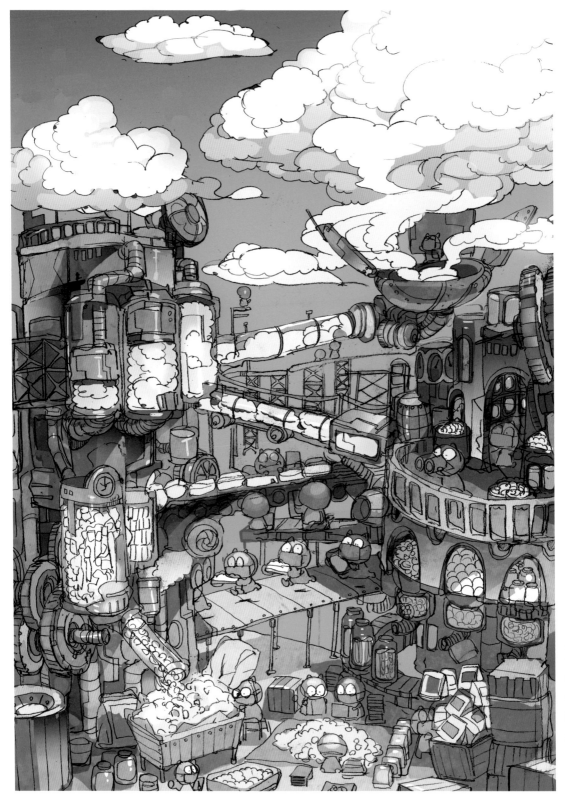

マシュマロ工場 — Marshmallow factory

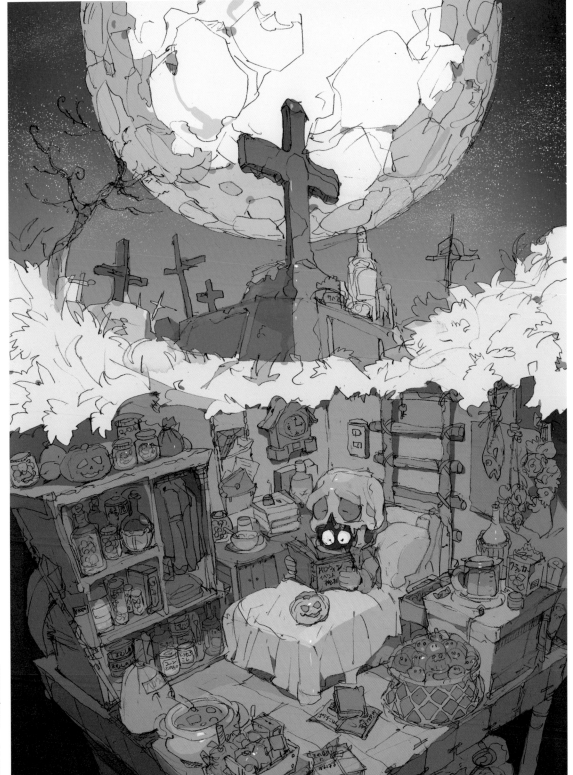

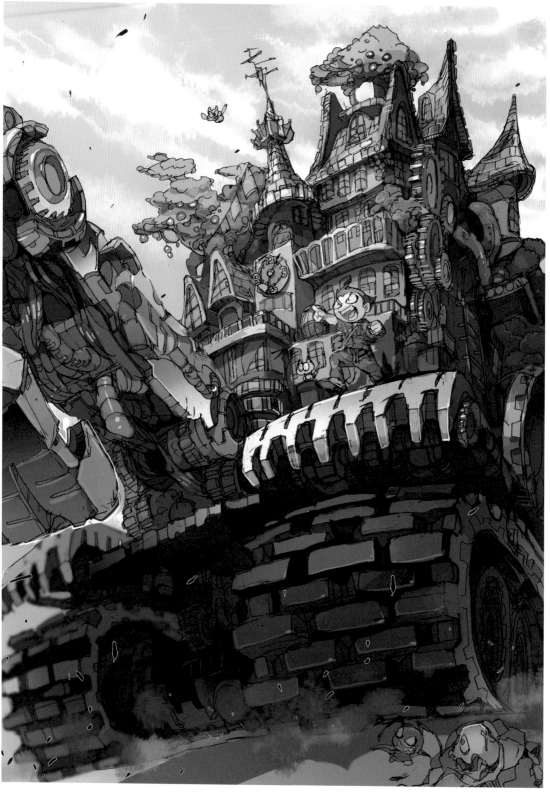

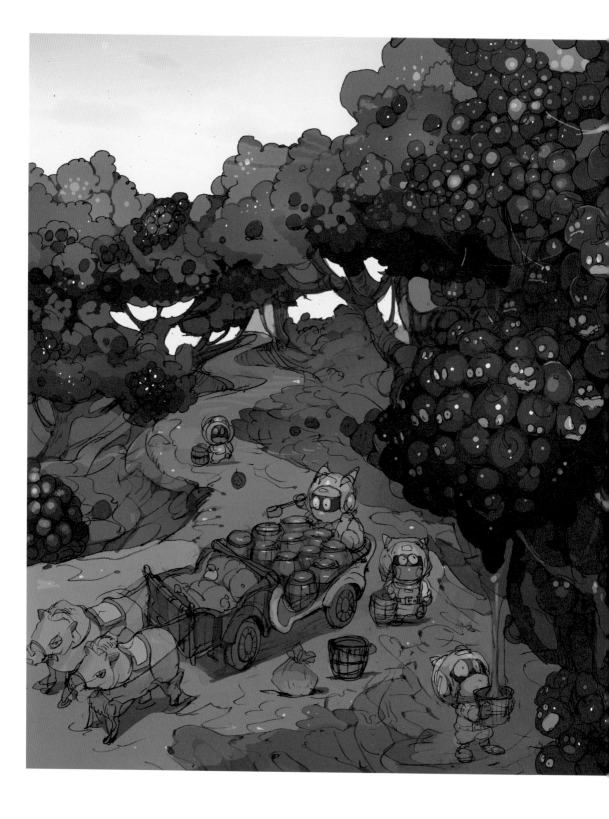

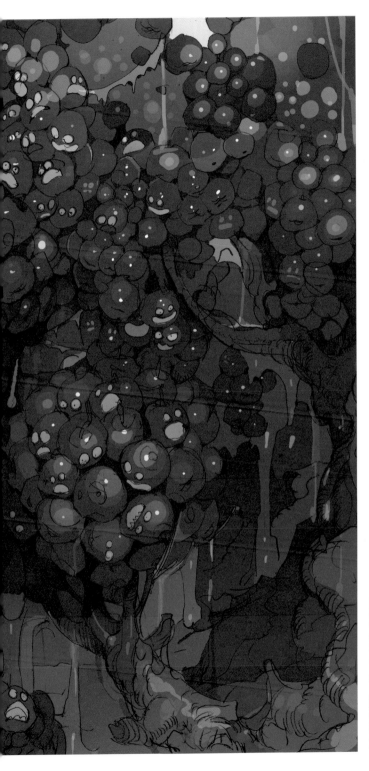

りんごであめ農場 ― Candy apple factory

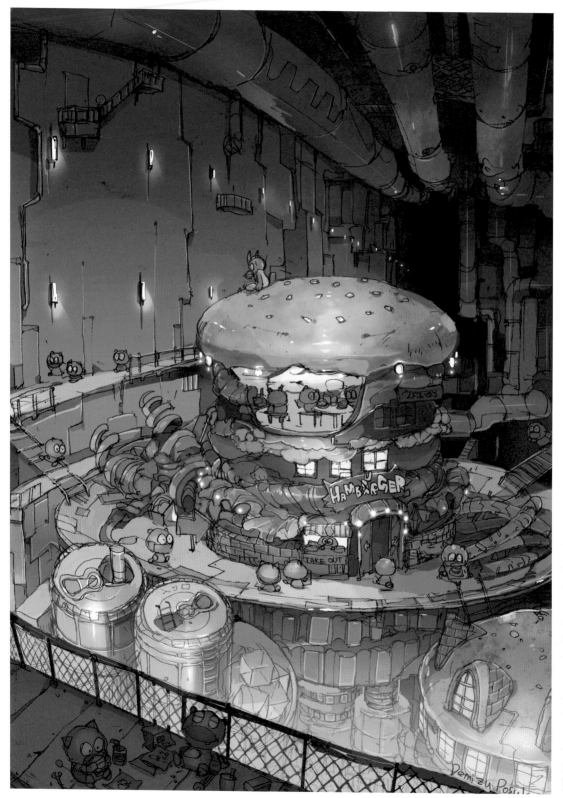

大型プラントのハンバーガーショップ ― Hamburger shop in a giant factory

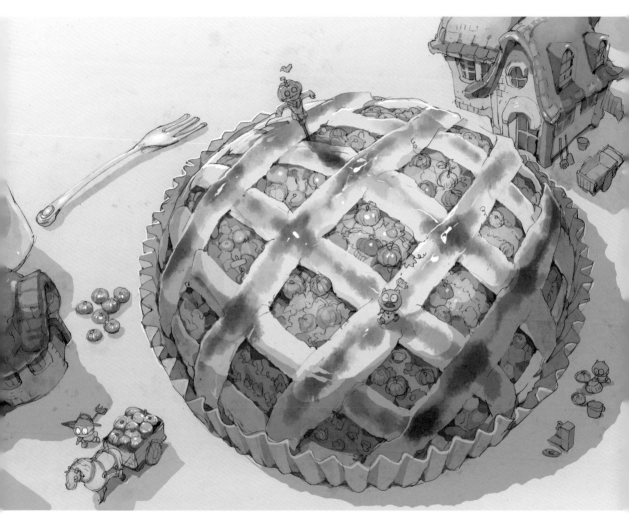

カボチャ畑のあぜ道 — Paths through a pumpkin field

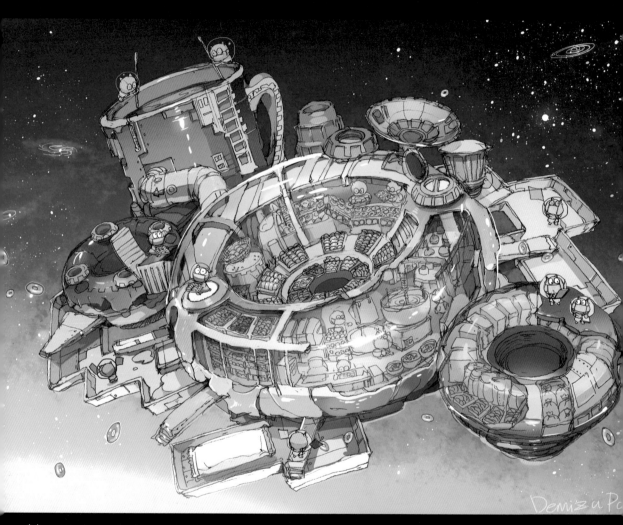

宇宙ドーナツステーション — Space station donut

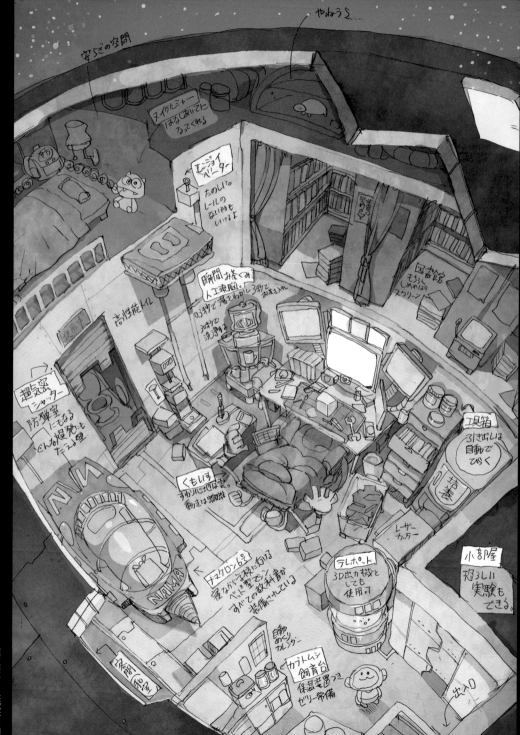

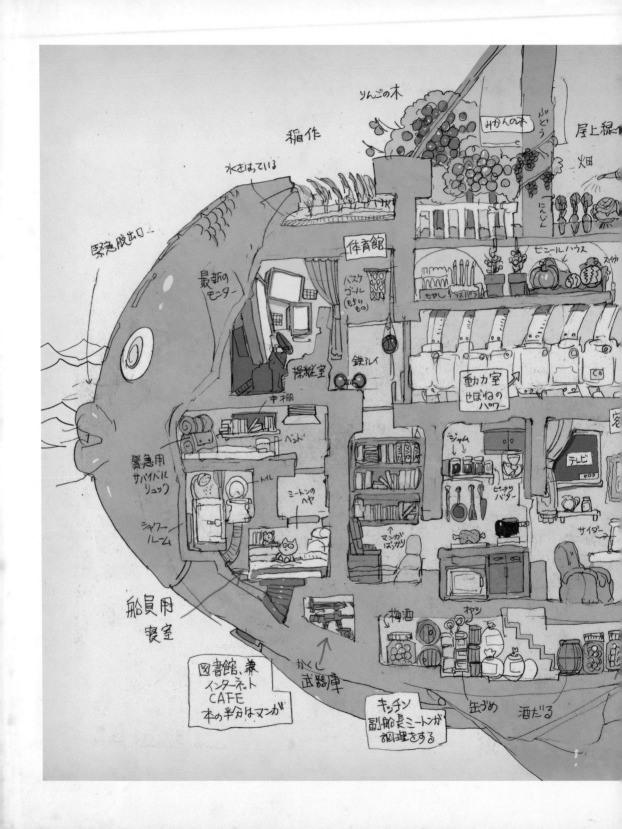

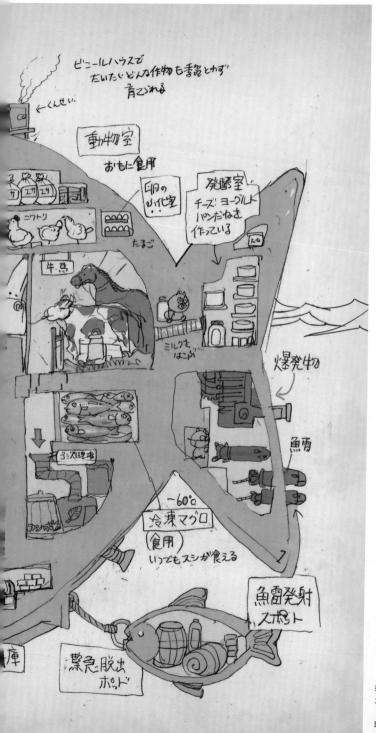

捕って良し、作って良し、
食べて良し、描いて良し（食べ物の魅力）。

It's fine to catch, fine to make,
fine to eat, and fine to draw (the charm of food).

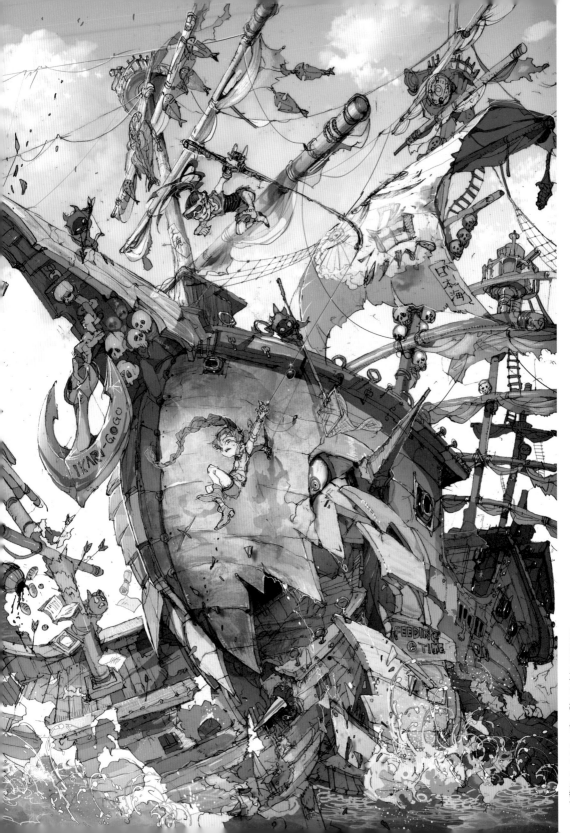

大荒れゴーストシップ —— Ghost ship rampage

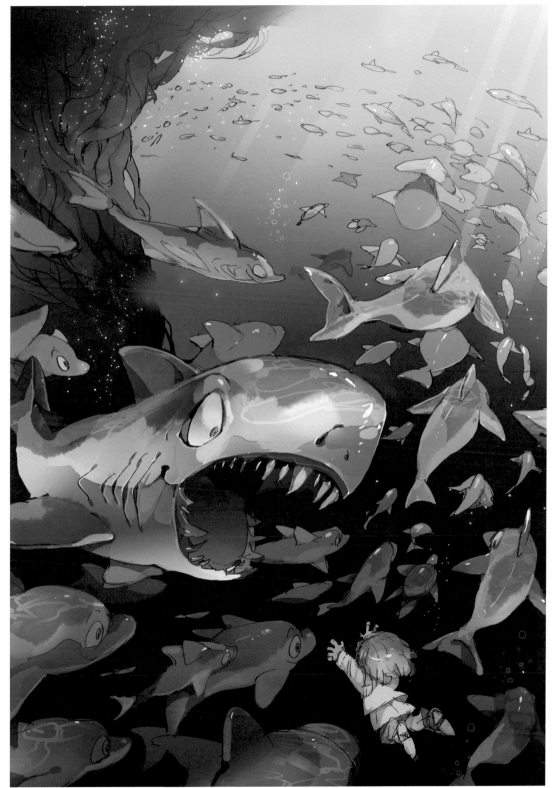

深海のパーティー —— Deep-sea party

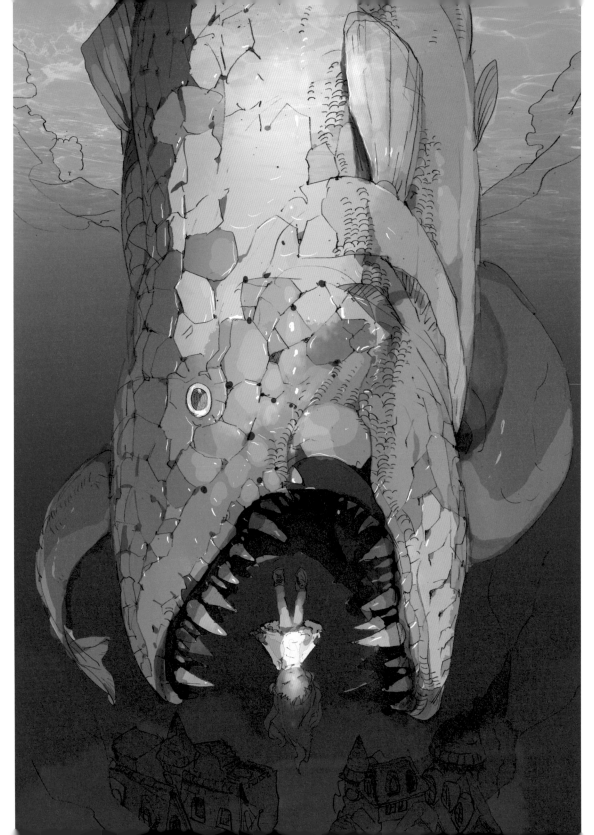

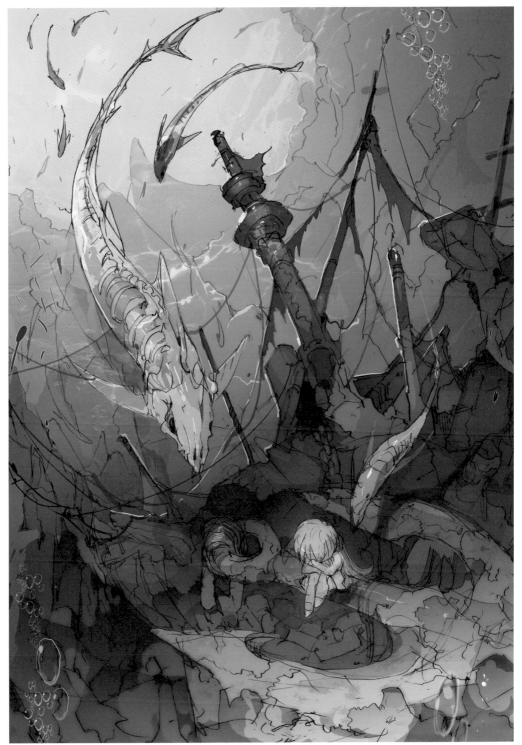

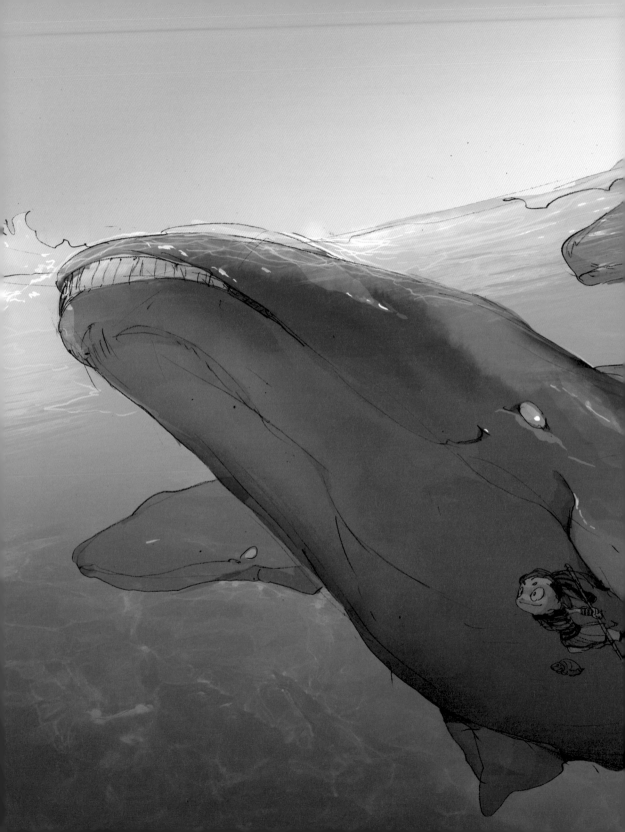

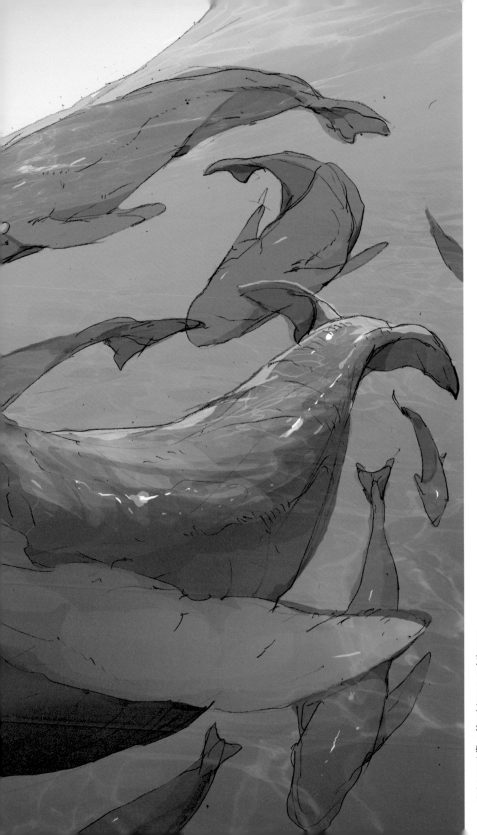

ウラシマルと海 — Urashimaru and the sea

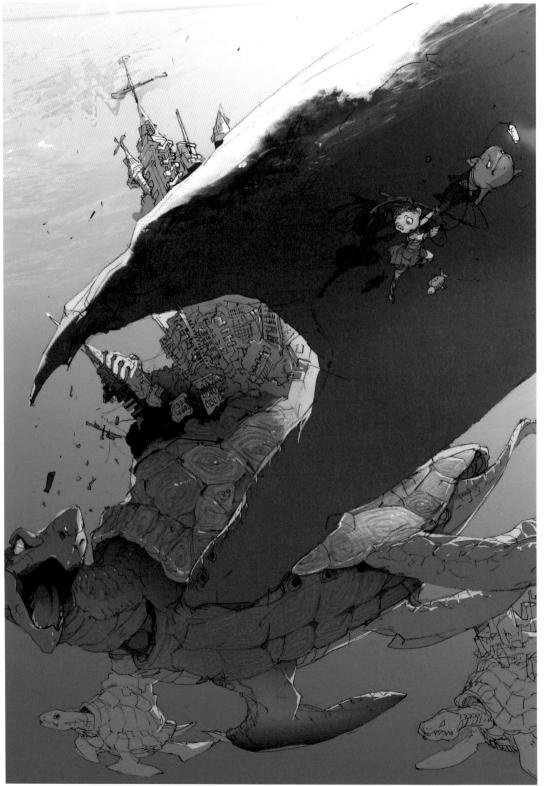

千年に一度沈む町 — A town submerged every thousand years

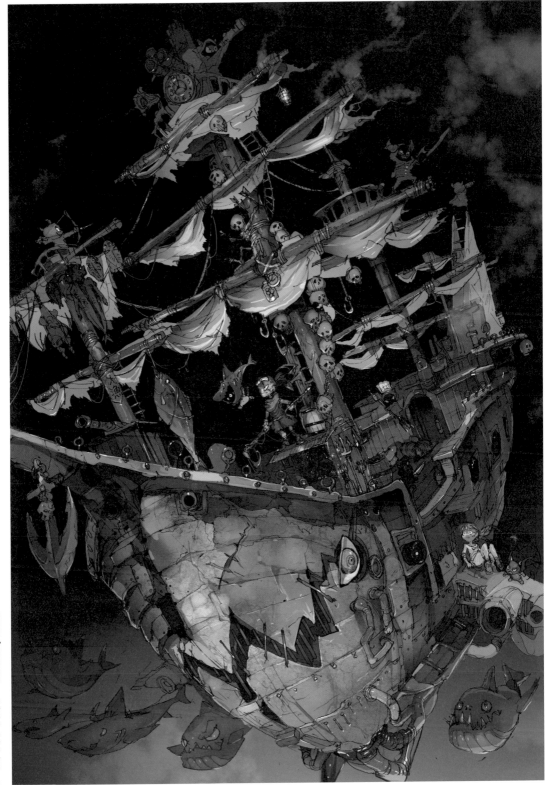

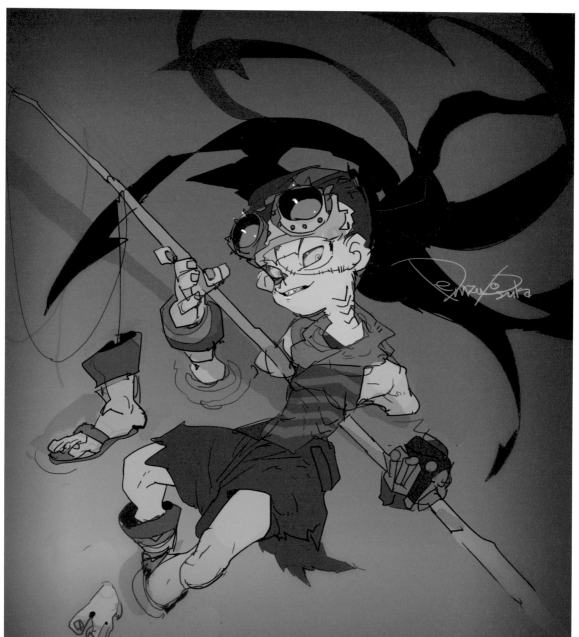

オバケ船長 — Spooky sea captain

ここ海底で、生きている人はそういない。人間がここで暮らしたきゃ、まずは命を落とすこと。
オバケになって本番だ。「死んだらおしまい」だなんて、ここじゃまだまだ素人さ。
一度や二度や三度でもその度に墓を這い上がれ。
それじゃあおまえは一度死んだ程度で、そう簡単に、あきらめてしまうのかい。

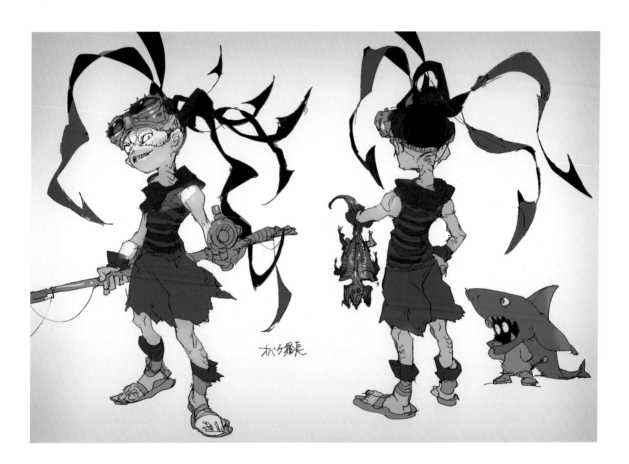

オバケ飛長

ここ海底で、生きている人はそういない。人間がここで暮らしたきゃ、まずは命を落とすこと。
オバケになって本番だ。「死んだらおしまい」だなんて、ここじゃまだまだ素人さ。
一度や二度や三度でもその度に墓を這い上がれ。
それじゃあおまえは一度死んだ程度で、そう簡単に、あきらめてしまうのかい。

Here underwater, there are no living people. The only way to live here is to first give up your life.
Ghosts are the main act. People who think, "death is the end," are still amateurs here.
Crawl out of your grave as many times as it takes: 1, 2, 3 times.
Are you going to just give up that easily after dying only once?

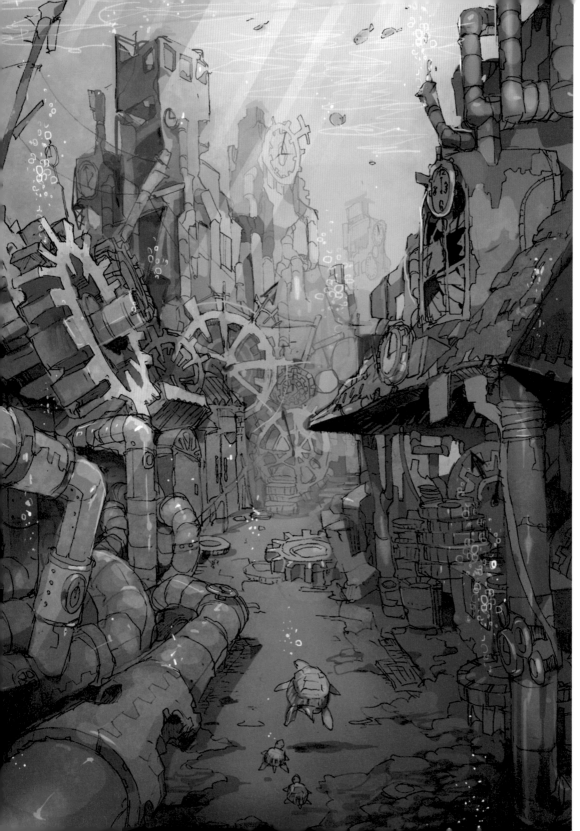

竜宮城 — Ryugu Castle

目を醒ませ、船だ！ — Wake up! A ship!

メカきち号 #1

・かめきちくんをモデルにしたメカ
・移動式住居

側面の甲らは
太陽パネルになっており
自家発電が可能
機体休止時は
太陽にむく。

遊具は
バイクか原付
一台だ

爪の矢は
マシンガン だが
使たためしがない…。

高性能
カメラを
そなえている

操縦室

たいていは
自動操縦（面倒くさがり）
眺めは抜群

住処をのぞくことはその人の心の内をのぞくみたいで、
住処をのぞかれることは心の内をのぞかれているみたいだ。

Looking into someone's home is
like looking into someone's heart,
and having someone look into your home is
like having someone look into your heart.

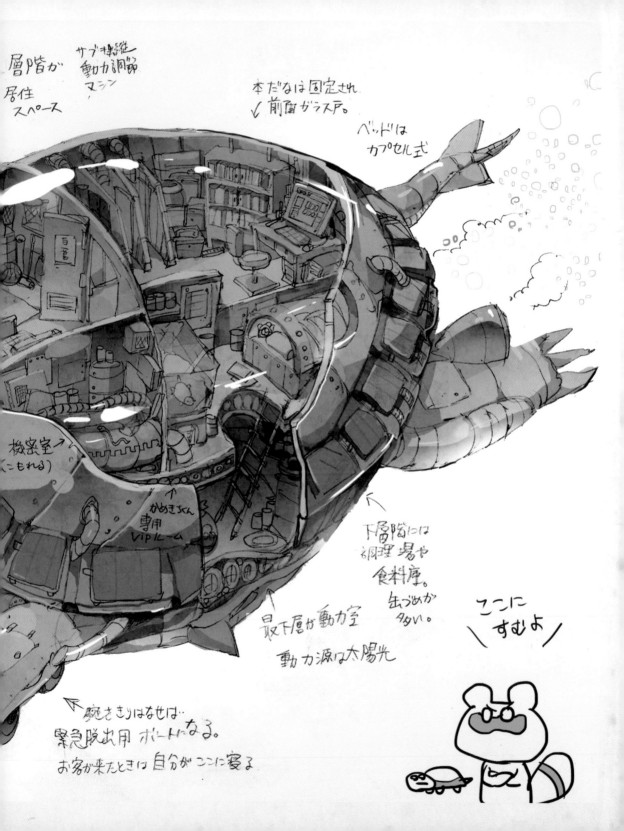

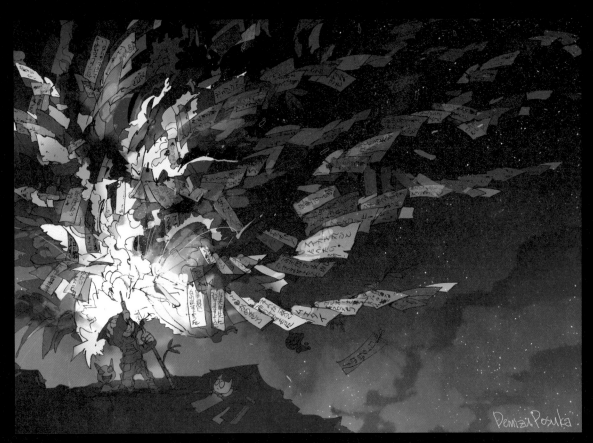

タナバタ — Tanabata Festival

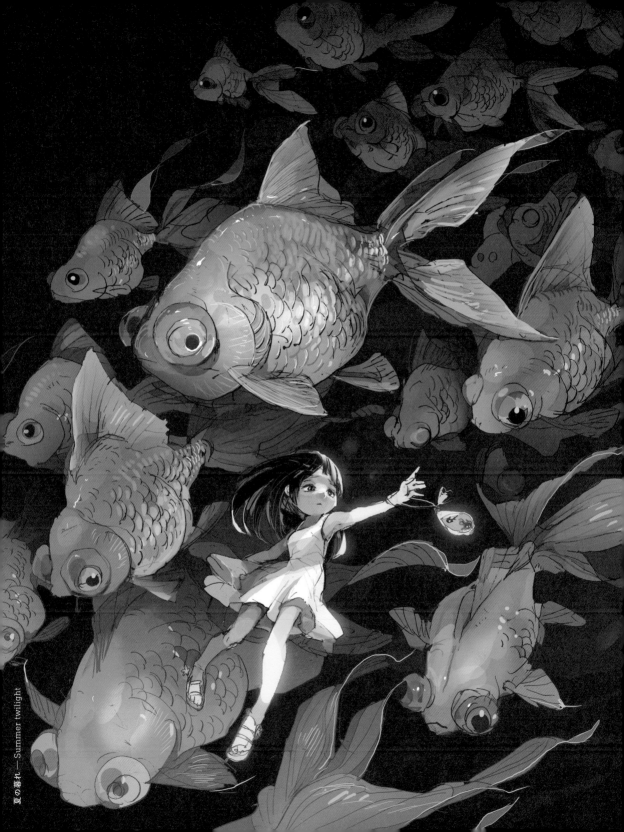

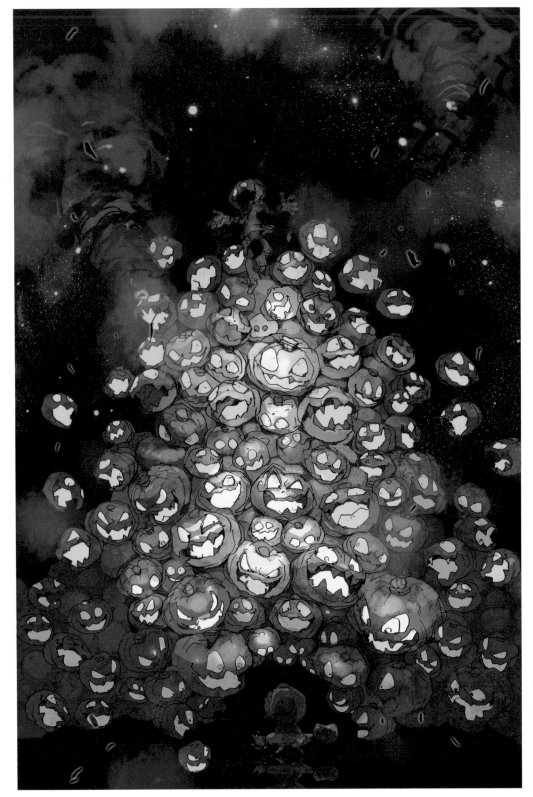

火葬パーティ ―― Cremation party

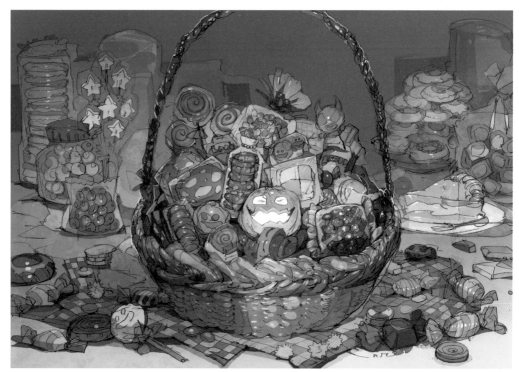

おかしな話 — Sweet talk

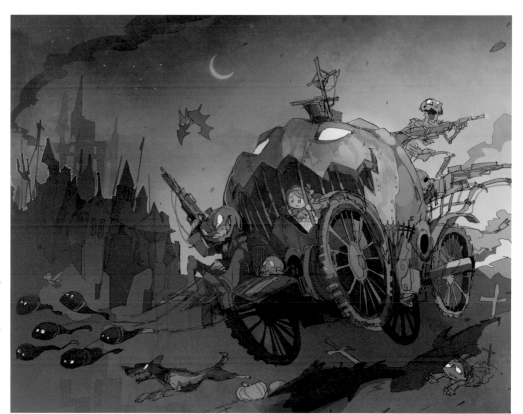

カボチャ馬車 — Pumpkin carriage

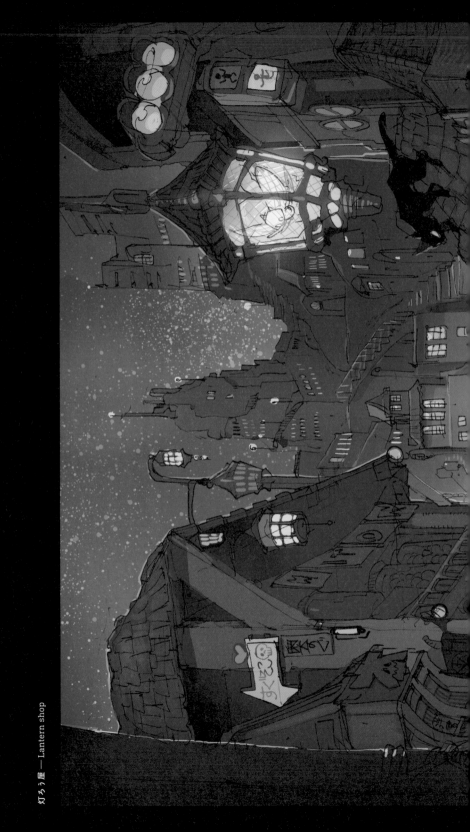

灯ろう屋 — Lantern shop

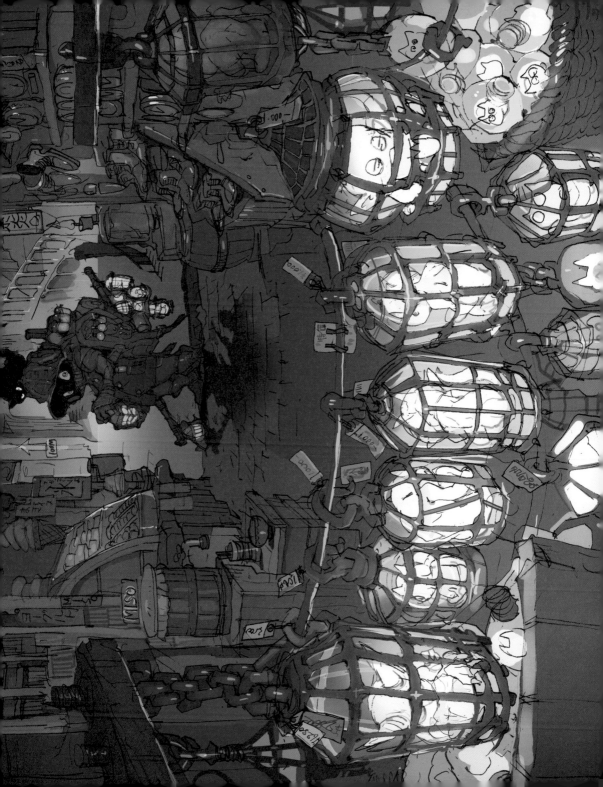

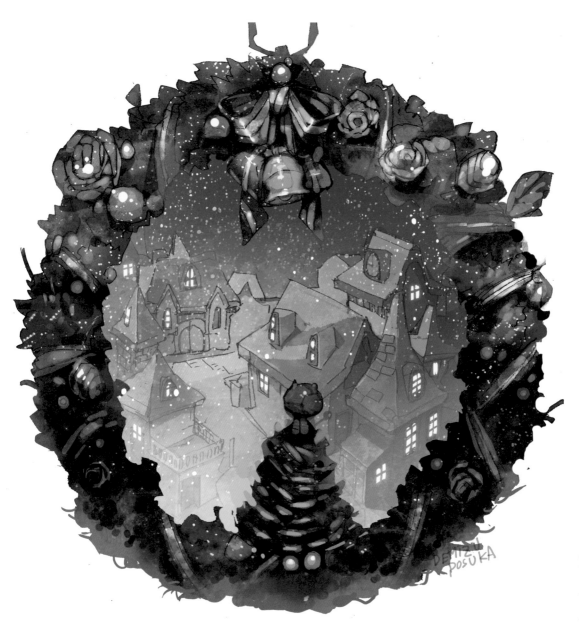

足元の夜と街に ―― In the night and town below

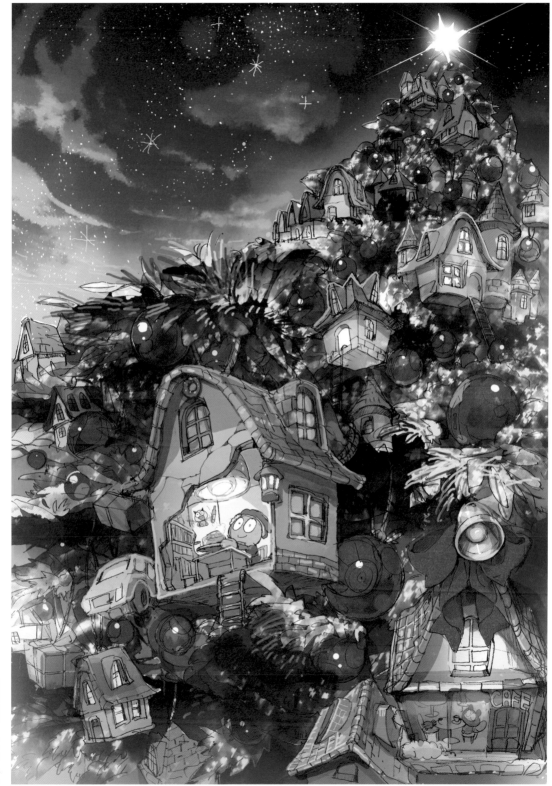

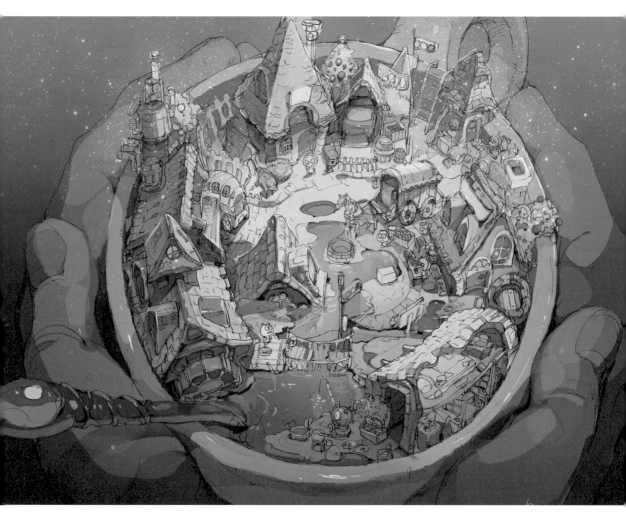

ミネストローネの街 ― Minestrone village

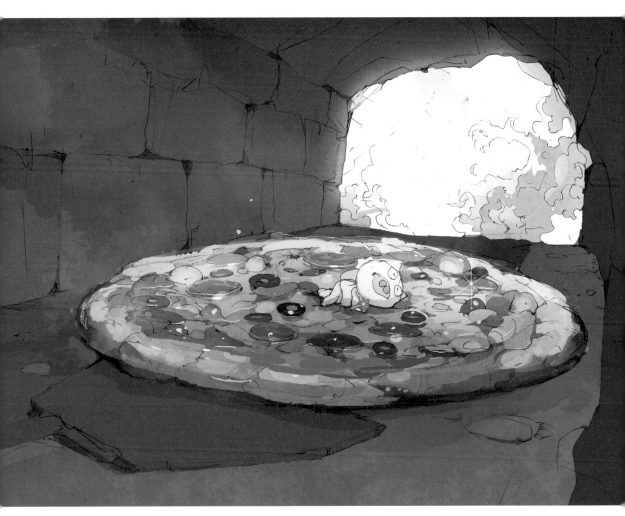

幸福な火葬 ― Blissful cremation

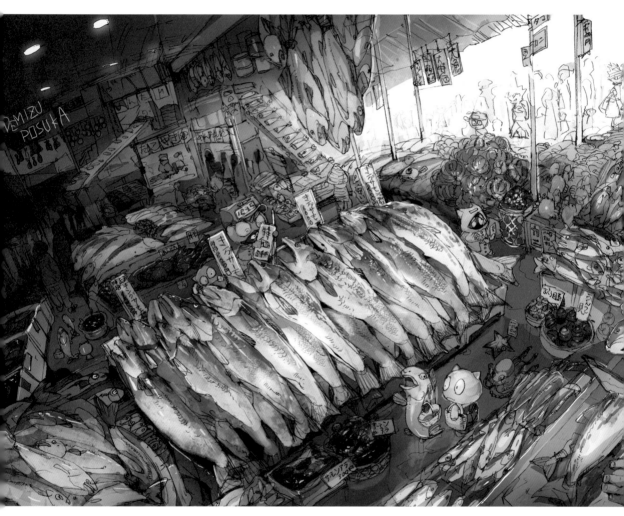

キングサーモンと年の暮れ — Year-end king salmon

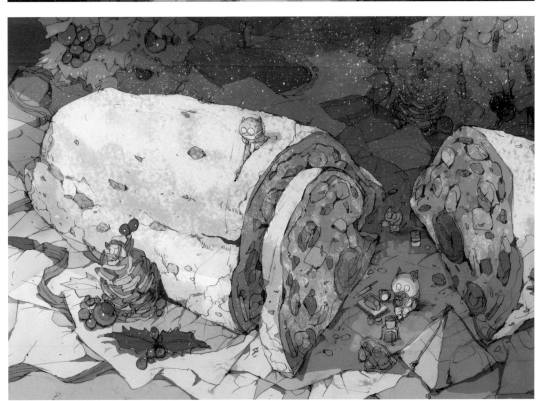

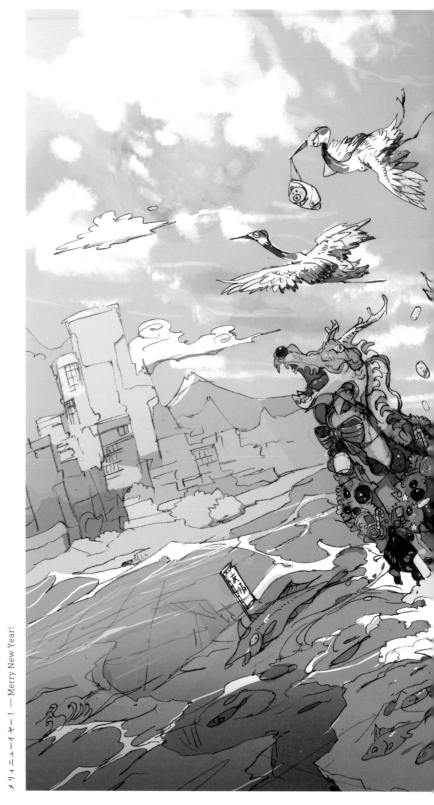

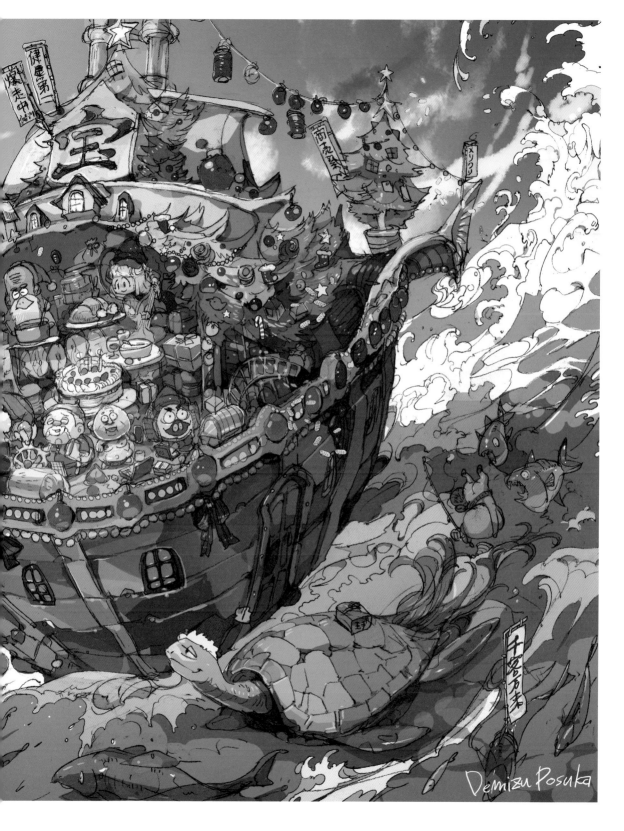

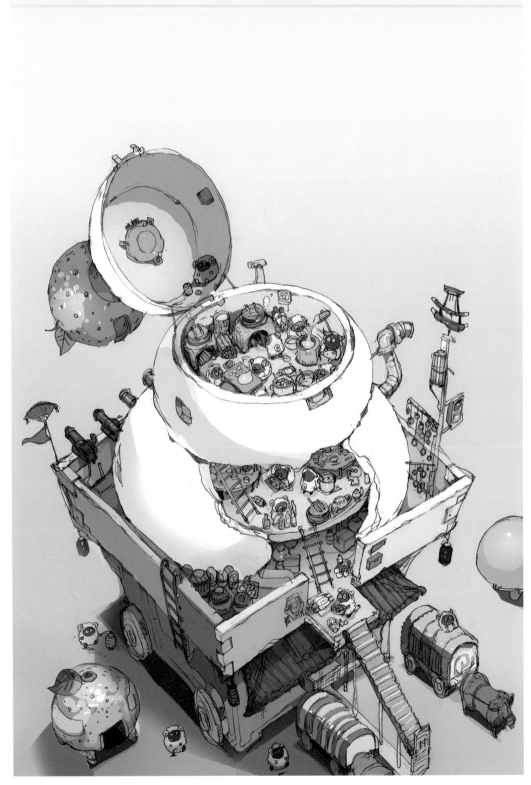

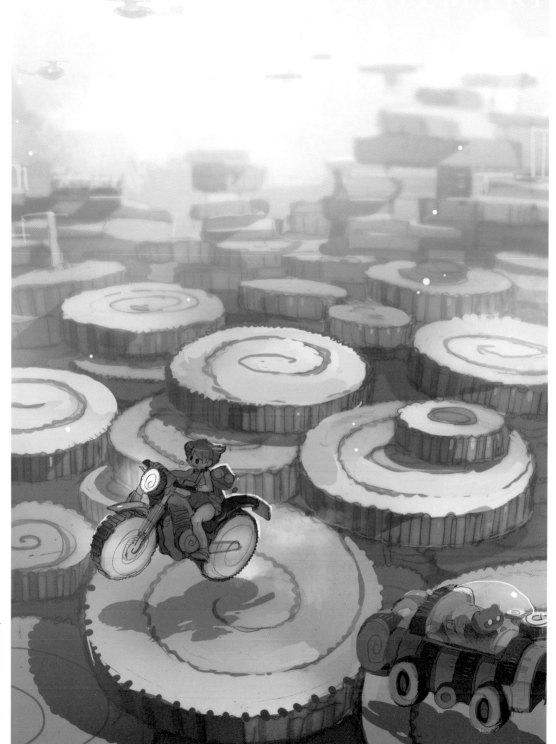

ダテマキシティ — Datemaki city

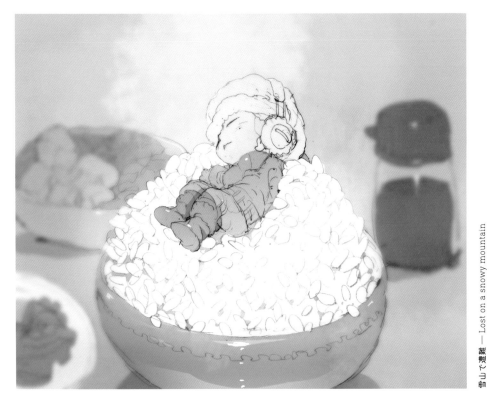

雪山で遭難 — Lost on a snowy mountain

オイルサーディン漁港 — Tinned sardine fishing port

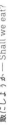

飯にしようかー Shall we eat?

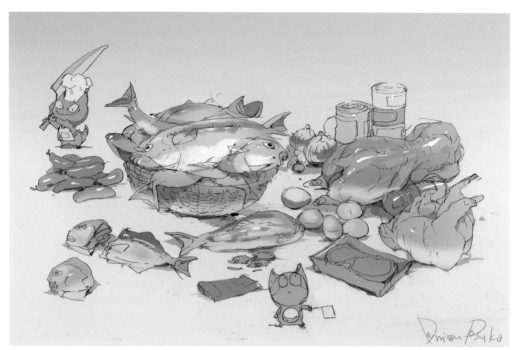

2014

実家の風呂はあったかいなー This bath at home warms like no other

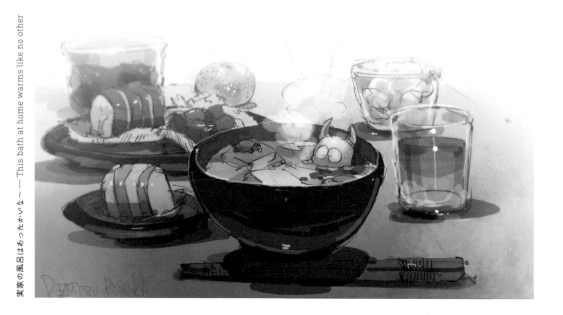

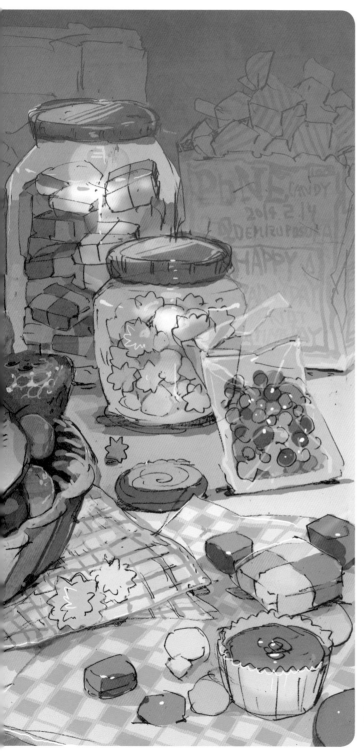

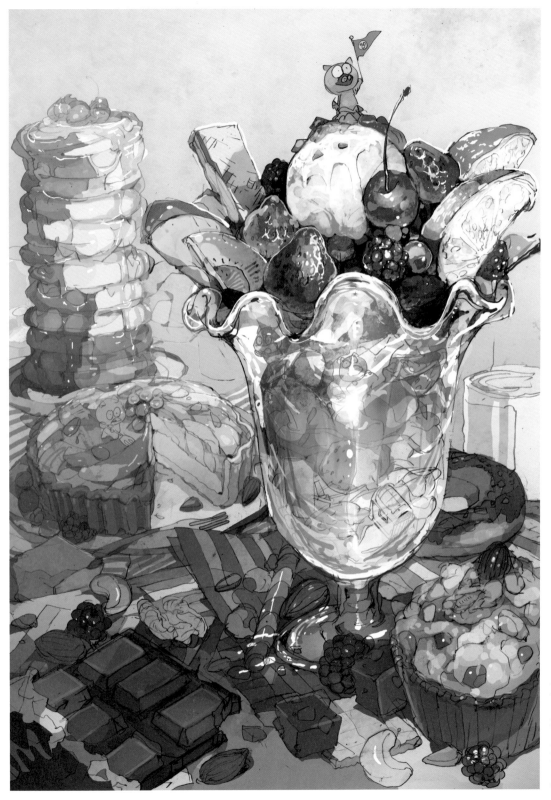

山のいただき ― Mountain bounty

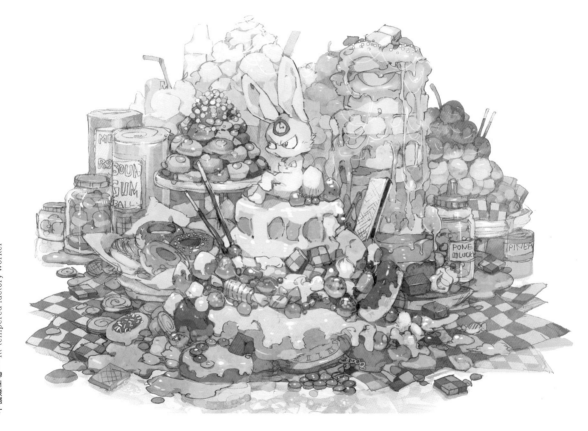

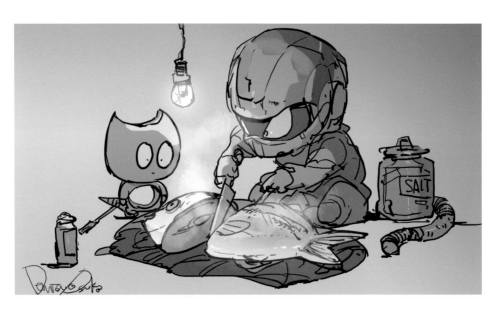

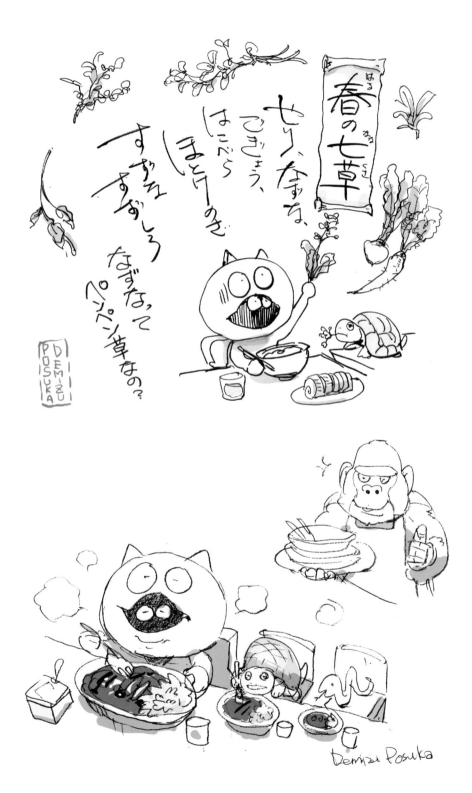

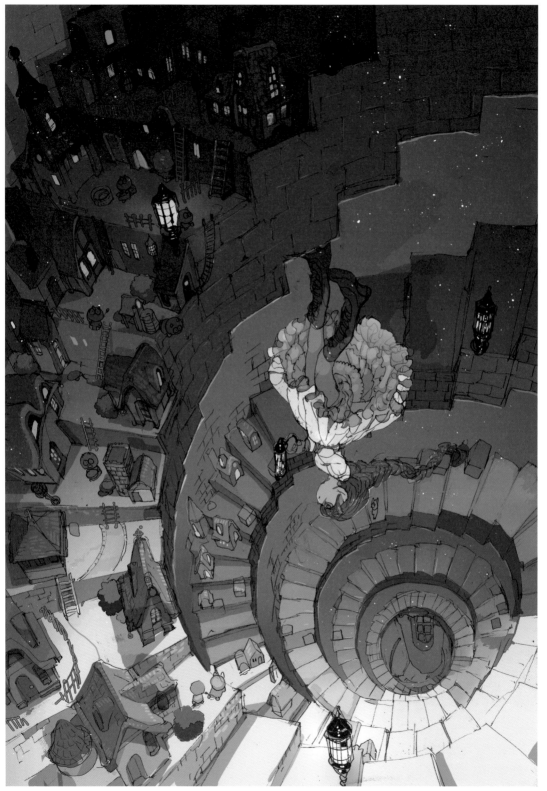

確かこのあたりと聞いたけれど —— It's supposed to me around here

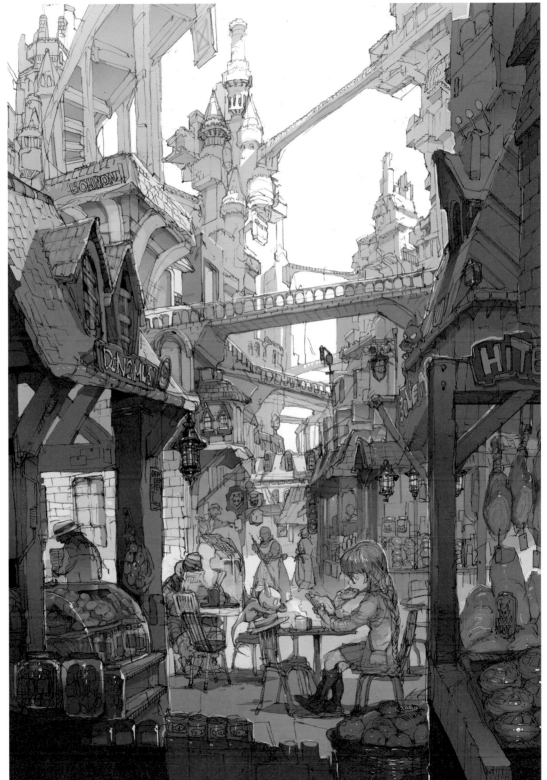

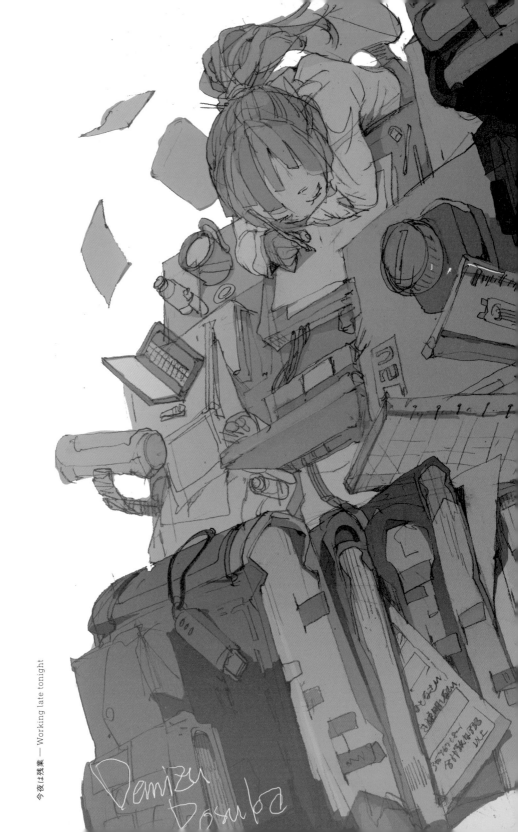

今夜は残業 — Working late tonight

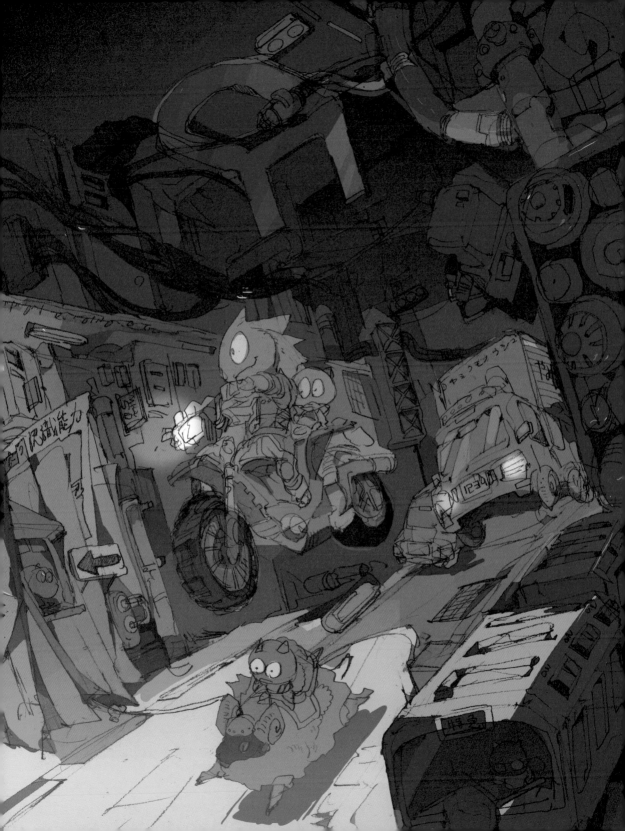

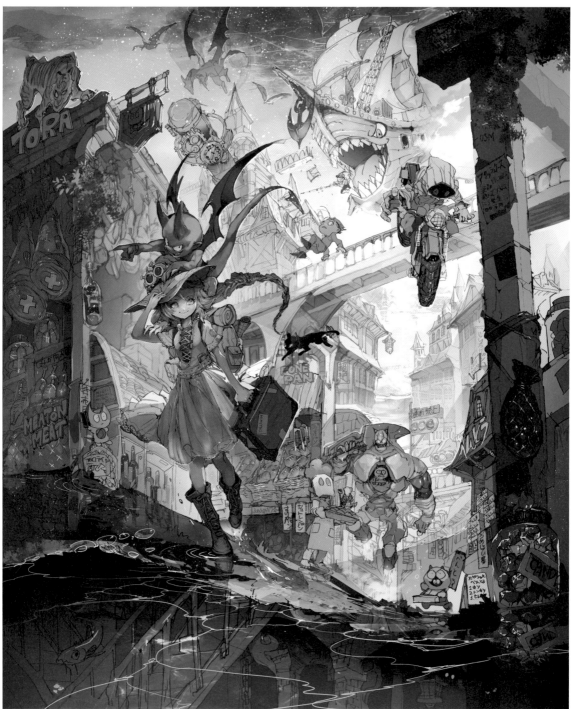

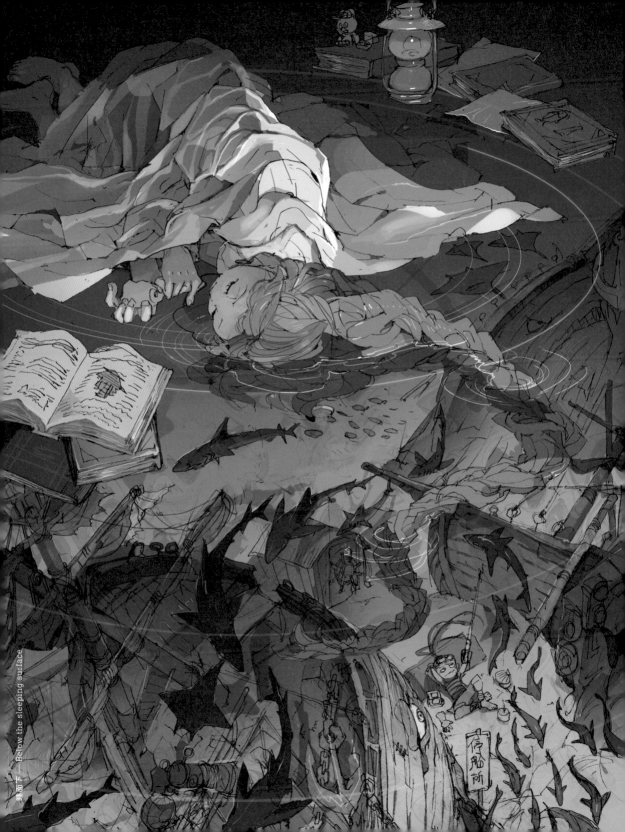

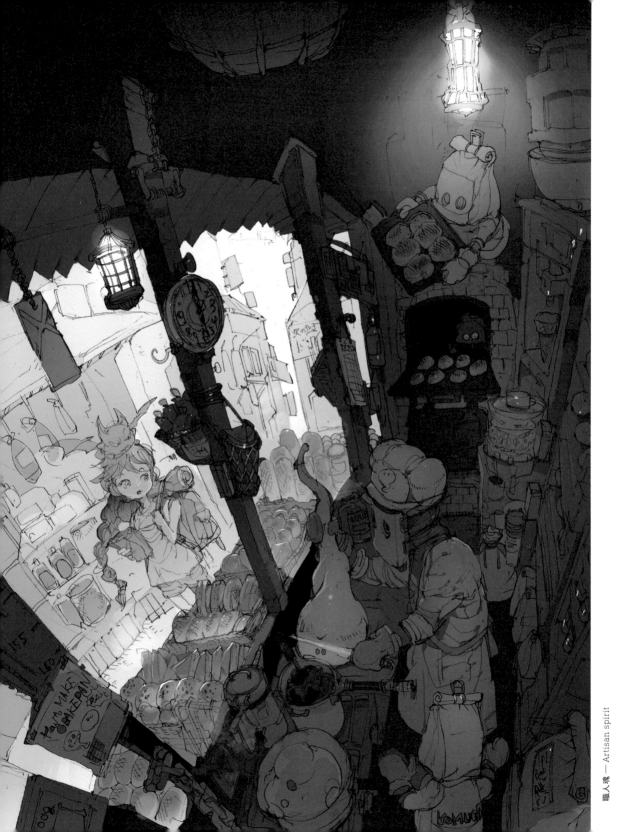

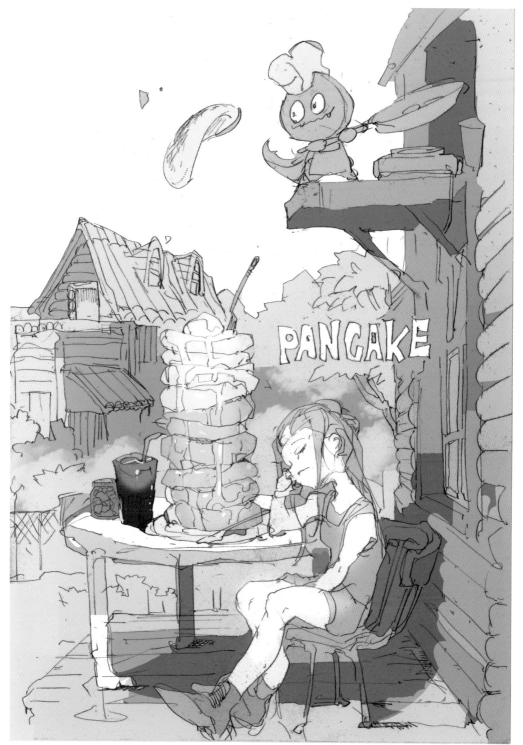

パンケーキ — Pancakes

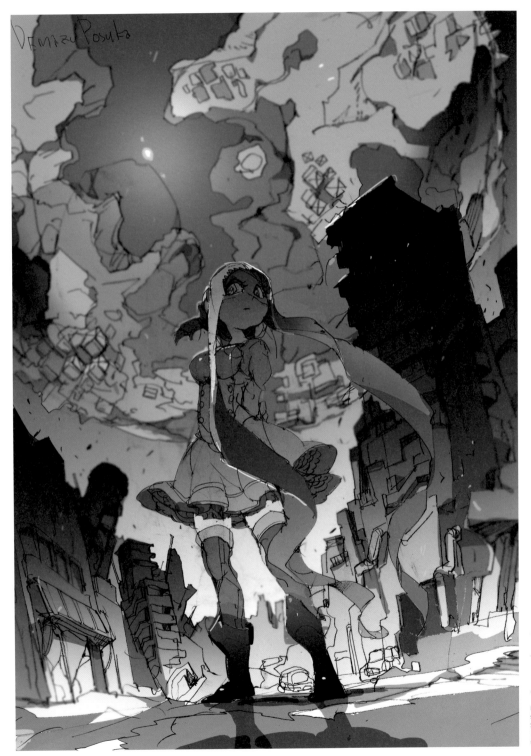

月面移住民— Lunar migrant

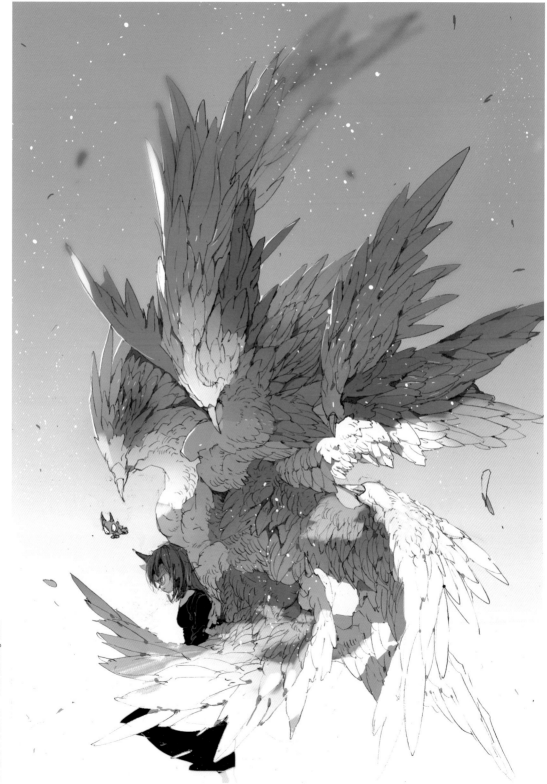

雪が解けるみたいに ― Like melting snow

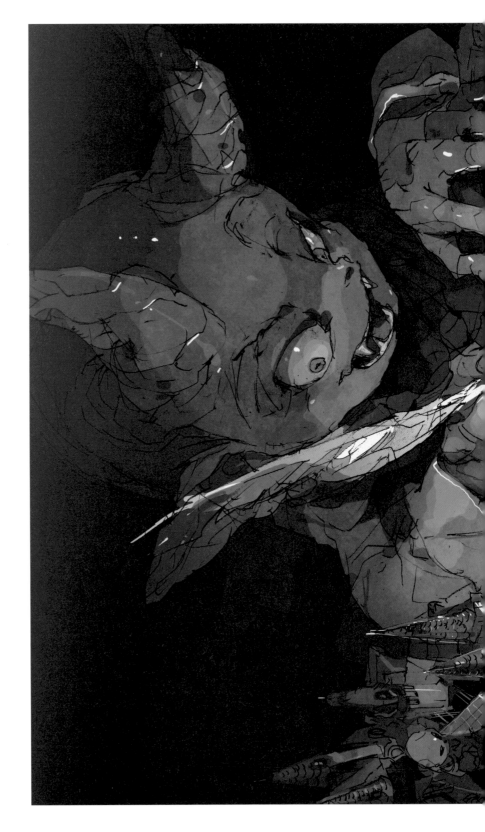

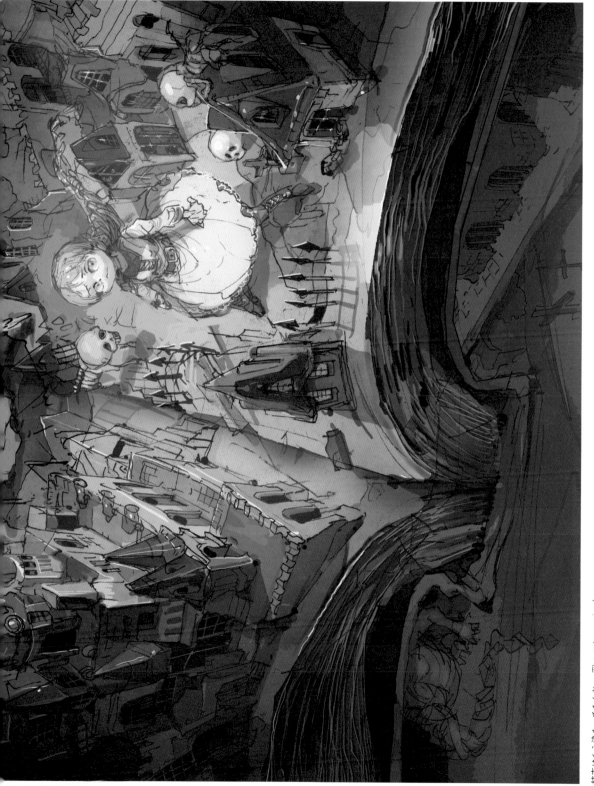

結末はもう決まってるんだ —The outcome is clear

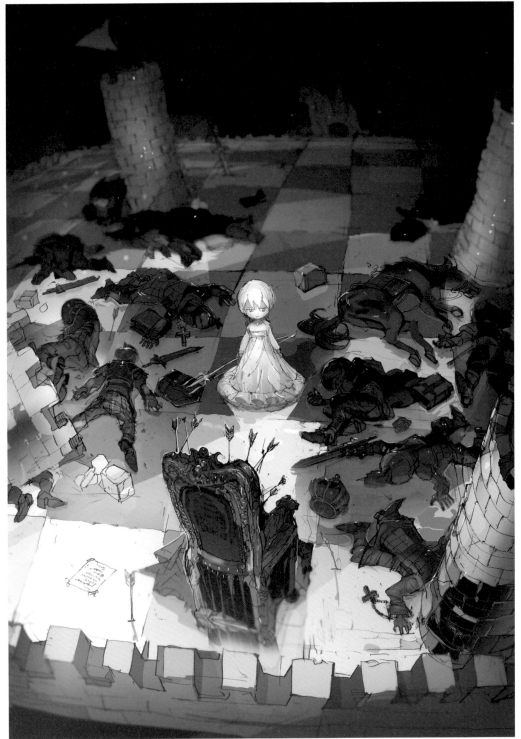

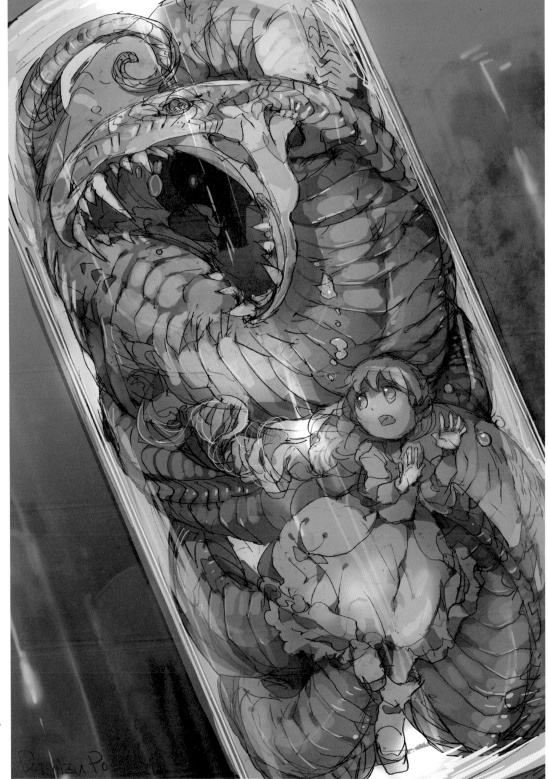

標本観察 — Specimen observation

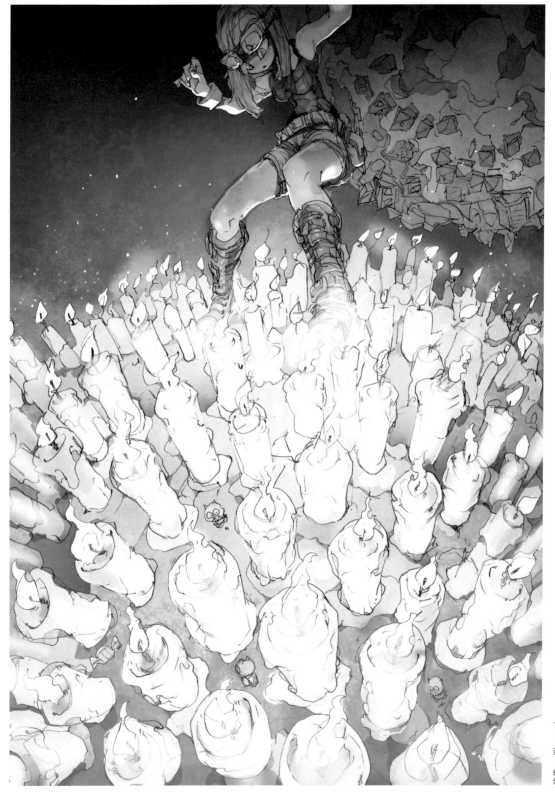

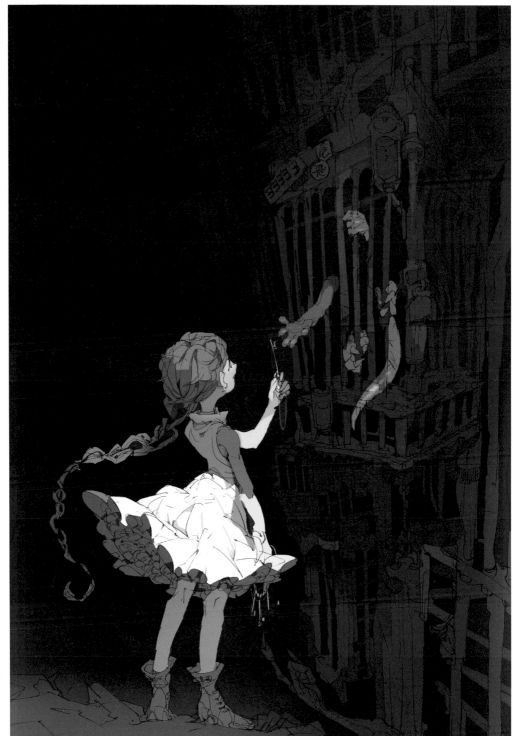

はやく — Quickly

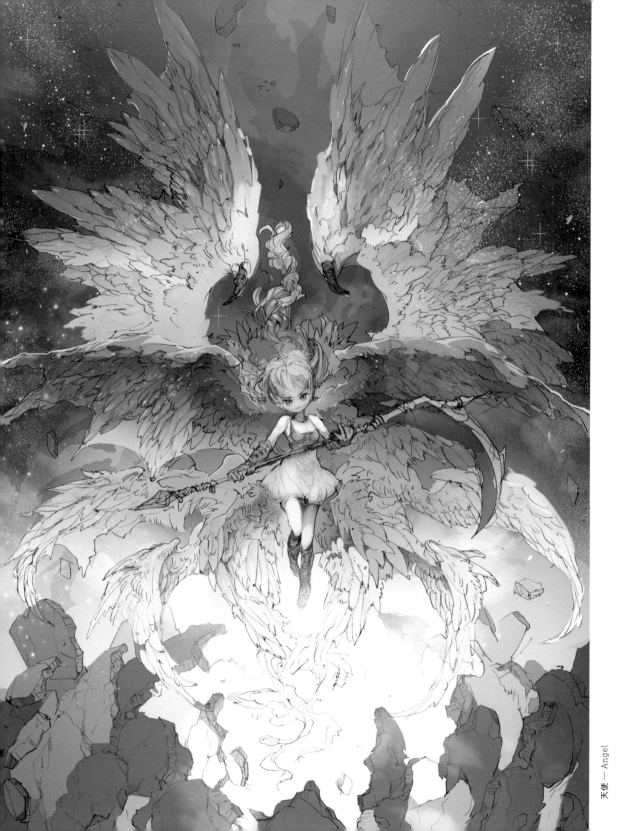

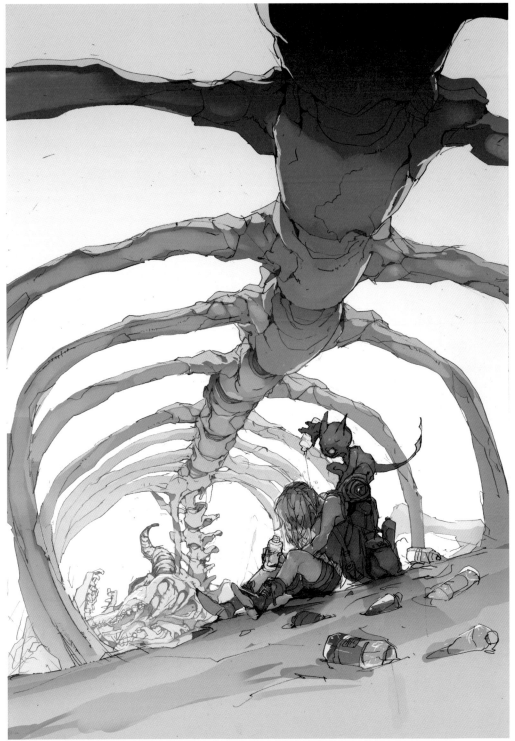

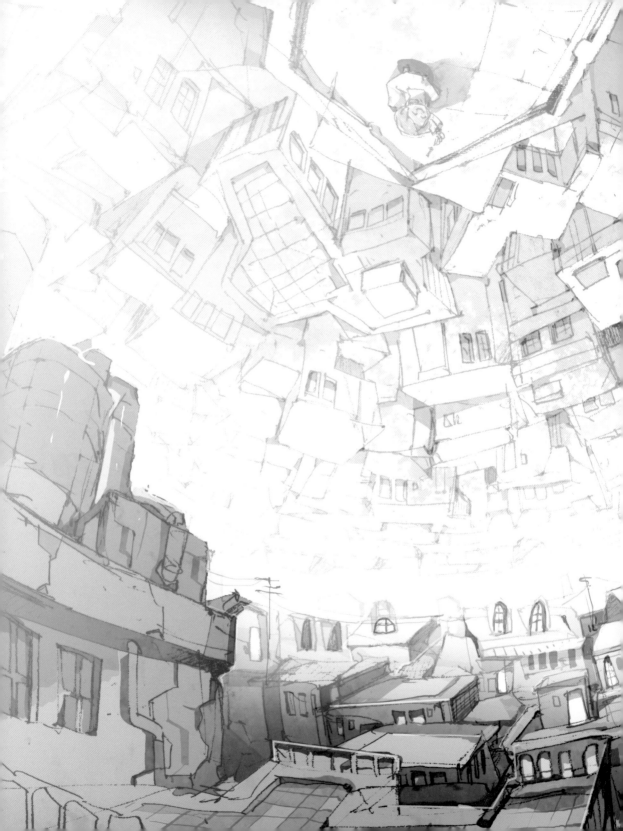

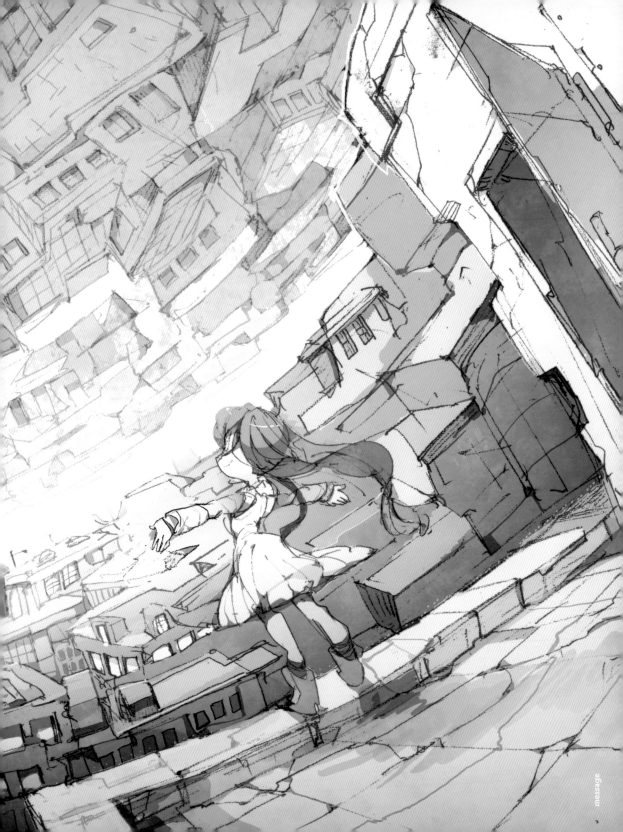

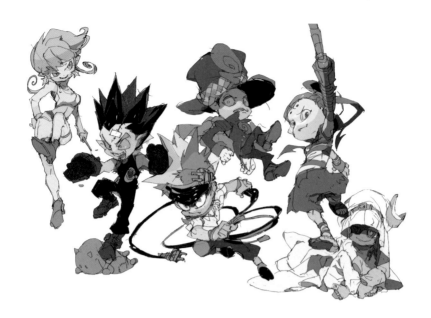

　不思議なことに、夏になると青い絵が増えて
冬になるとオレンジの絵が増えるのです。

　夏は海に行きたいし、冬はストーブの前に座りたい、といつも考えているので
そのときの希望や考えが、絵の中に露骨に反映されるみたいです。
そんなふうに、本書に収録した絵は日々思うことなどを書きためた「日記」みたいなものです。
絵を見ていると、だいたいそのとき何があったのかとか、どんなことをしていたのかを思い出します。

　『ＰＯＮＥ』というタイトルは絵を描くために使った、最初のペンネームからとりました。
そのときの読者は、友達２人でした。

　ほとんどの絵は日々の生活から着想を得ています。
もし毎日が退屈だったら、いくら時間があっても、絵を描くことはないでしょう。
毎日の中には、言いたくても言えないこともいっぱいあって、
そういうフラストレーションから絵が生まれることも数多くあります。

　攻撃的な絵を描いたとき「だれか殴りたい相手がいるの？」と聞かれ、嬉しかったものです。
まるで自分がとても強い者だと思われているみたいでしたから。
決して「殴られている方が自分だ」とは言いませんでした。

　絵の仕事をはじめてからたくさん作品を作ってきましたが、全部を見ていただく必要はありません。
もし、どれか一枚だけでも好きだなぁと思ってもらえる絵があったら、
たぶん、その日私の身にあったことや考えたことと、あなたが今日考えたことが一致したのかもしれません。
幸せなことです。
どの絵か教えてくださいますか。

　本書をお手に取っていただき、ありがとうございます。
これからもどうぞよろしくお願いいたします。

出水ぽすか

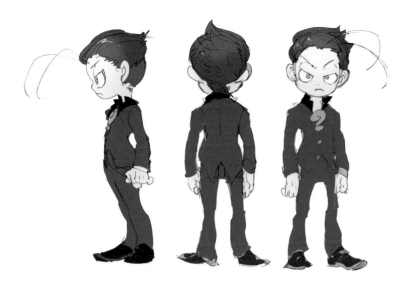

It's a curious thing that in summer, blue drawings are everywhere,
and in winter, orange seems to prevail.

In summer, I want to go to the beach, and in winter, I want to sit in front of the fire. It's always on my mind at the time,
so my current desires end up explicitly effecting my drawing.
That's why a book of drawings ends up resembling a kind of diary of everyday thoughts.
When I look at these drawings, I can mostly remember what was going on at the time and what I was doing then.

The title, PONE, was the first penname I used for drawing.
At the time, only two of my friends knew about my work.

Most of the drawings take inspiration from day to day life. If every day was boring,
I wouldn't draw anything even if I had the time. But actually, there are so many things I want to say but can't every day,
and this frustration has led to the creation of many of these drawings.

When I draw an aggressive drawing, it makes me happy when I'm asked,
"Do you want to punch someone?",
because that person thinks that I'm quite a strong person.
Of course I never tell them that I'm the one who is being punched.

Since I started, I've created a lot of drawings, but you don't have to see all of them.
If just a single drawing makes someone happy,
it may mean that whatever I was experiencing or thinking about at the time is the same as what you were thinking about today.
That makes me very happy. Please let me know what drawing you like.

Thank you for giving this book a look,
and I hope you'll enjoy it and other works in the future.

出水ぽすかアートブック ポ〜ン

2016 年 11 月 25 日　初版第 1 刷発行
2021 年　5 月　8 日　　　第13刷発行

著　者	出水ぽすか		協　力	アスキー・メディアワークス
デザイン	杉山峻輔			さくら荘製作委員会
翻　訳	パメラ・ミキ			株式会社 小学館
	クリスチャン・トレイラ			StrangeArtifact
	ブレインウッズ株式会社			ダイハツ工業株式会社
編　集	杵淵恵子			辰巳出版株式会社
				buzzG
発 行 人	三芳寛要			ピクシブ株式会社
発 行 元	株式会社 パイ インターナショナル			melost

〒170-0005　東京都豊島区南大塚 2-32-4
TEL 03-3944-3981
FAX 03-5395-4830
sales@pie.co.jp

印刷・製本　　株式会社 廣済堂